Allen W. Seaby
Art and nature

Martin Andrews was a museum and exhibition designer for many years and since 1990 has been a Lecturer in the Department of Typography & Graphic Communication at the University of Reading. He is a printing historian, has lectured widely in Britain and abroad and published numerous articles as well as *Fox Talbot & the Reading Establishment* (Two Rivers Press, 2014) and an extensive biography of the author and artist Robert Gibbings.

Robert Gillmor is a founder member and former president of the Society of Wildlife Artists (SWLA). He is a keen ornithologist and has served on the Councils of all three of the national organisations: the RSPB, the British Ornithologists' Union and the British Trust for Ornithology. His artistic output has been enormous and in a variety of forms, including line drawing, watercolour and linocuts. His work has appeared in over 150 books.

Martin and Robert are both heirs to Allen W. Seaby as Presidents of the Reading Guild of Artists – Robert from 1969 to 1984 and Martin, the current President, from 2012.

ALSO PUBLISHED BY TWO RIVERS PRESS:

Reading Detectives by Kerry Renshaw
Fox Talbot & the Reading Establishment by Martin Andrews
Cover Birds by Robert Gillmor
All Change at Reading: The Railway and the Station 1840–2013
by Adam Sowan
An Artist's Year in the Harris Garden by Jenny Halstead
Caversham Court Gardens: A Heritage Guide by Friends of Caversham
Court Gardens
Believing in Reading: Our Places of Worship by Adam Sowan
Newtown: A Photographic Journey in Reading 1974 by Terry Allsop
Bikes, Balls & Biscuitmen: Our Sporting Life by Tim Crooks & Reading Museum
Birds, Blocks & Stamps: Post & Go Birds of Britain by Robert Gillmor
The Reading Quiz Book by Adam Sowan
Bizarre Berkshire: An A–Z Guide by Duncan Mackay
Broad Street Chapel & the Origins of Dissent in Reading by Geoff Sawers
Reading Poetry: An Anthology edited by Peter Robinson
Reading: A Horse-Racing Town by Nigel Sutcliffe
Eat Wild by Duncan MacKay
Down by the River: The Thames and Kennet in Reading by Gillian Clark
A Much-maligned Town: Opinions of Reading 1126–2008 by Adam Sowan
A Mark of Affection: The Soane Obelisk in Reading by Adam Sowan
The Stranger in Reading edited by Adam Sowan
The Holy Brook by Adam Sowan
Charms against Jackals edited by Adam Stout and Geoff Sawers
Abattoirs Road to Zinzan Street by Adam Sowan

Allen W. Seaby

Art and nature

Martin Andrews
& Robert Gillmor

TWO
RIVERS
PRESS

First published in the UK in 2014 by Two Rivers Press
7 Denmark Road, Reading RG1 5PA
www.tworiverspress.com

ISBN 978-1-909747-05-0

1 2 3 4 5 6 7 8 9

Two Rivers Press is represented in the UK by Inpress Ltd
and distributed by Central Books.

Cover illustration: detail of *Lapwings* by Allen Seaby, colour woodcut, late 1920s
Text and cover design by Nadja Guggi and typeset in Pollen and Museo

Printed and bound in Great Britain by Ashford Colour Press, Gosport

Acknowledgements

This book is the result of a very enjoyable collaboration between the authors and has been made possible by the support and contributions of a number of individuals and organisations. Our thanks go to all at the Two Rivers Press and especially to Nadja Guggi for her superb design and to Anke Ueberberg for her editorial role.

The publishing of the book coincides with a major exhibition of Allen Seaby's work held at Reading Museum from 11 October 2014 to 22 March 2015. It was Elaine Blake, Exhibitions & Partnerships Curator, who initiated the idea of the book, and we are most grateful to her and the Museum for permission to reproduce so many of the images from the Museum's Seaby collection. Thanks also go to the University of Reading, Special Collections and Ladybird Books Ltd for permission to reproduce artwork from the Ladybird books, and the Department of Typography & Graphic Communication for material from the Seaby archive in the Department's collection centre.

Notes

Unfortunately Seaby rarely dated his work so in some cases an approximate date has been given on the basis of general evidence and circumstances. The material illustrated in the book has come from four main sources which have been referred to by initials in the captions: the family archive held by Robert Gillmor as GC; the Museum of Reading as RM; the Seaby archive in the Department of Typography & Graphic Communication as T & GC; the University's Special Collections as RUSC. The dimensions of materials have been given with height followed by width.

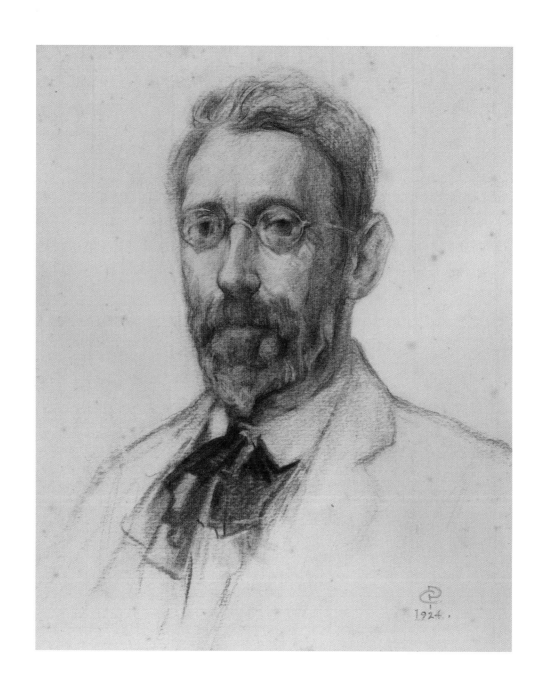

1924.

Contents

Portrait of Allen Seaby, 1924, an excellent likeness
by Cyril Pearce
Pencil and conté crayon, 254×194 mm (GC)

For the Grandchildren,
Great-Grandchildren and
Great-Great-Grandchildren
of Allen and Ada Seaby

Allen Seaby: a memoir of my grandfather

by Robert Gillmor

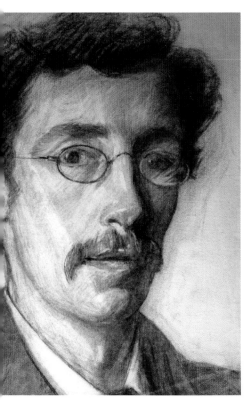

Portrait of Allen Seaby, c.1890s
Artist unknown; possibly by a colleague
at the Art School, or, more likely a self-portrait
Charcoal drawing, 356×238mm (T & GC)

Allen Seaby's life has been described by Nicholas Hammond, in a book published in 1986, as 'a classic tale of Victorian self-improvement.' Cathy Sloane (1995), taking up this point, wrote 'But as the life of this early twentieth century artist unfolded I became aware that there was more to the tale than just "self-improvement." Seaby was a pioneering, innovative and inspirational man whose work breathed new life into the genre of bird painting.'

Today his name is probably best known as a bird painter, based on the set of plates he painted for *The British Bird Book: An account of all the birds, nests and eggs found in the British Isles*, edited by F.B. Kirkman, which appeared in 12 parts between 1910 and 1913. He did the bulk of the illustrations, about 65 per cent – some 135 paintings – several of which are now in the collection of Reading Museum. Surprisingly, he did little more in the way of bird paintings for publication until the 1950s, in the last few years of his life. The ornithological scene in the early twentieth century was much smaller, and very different from the way it was to develop, and Seaby was never really part of it anyway. He knew and corresponded with several distinguished ornithologists, but it was his work as a teacher in Reading that was truly significant, and it was his devotion to the craft of the colour woodcut print, throughout his life, that probably represents his most enduring contribution to British art.

In writing this piece I was frustrated at how little I can find about Seaby's early life, other than the bare skeleton. I really have little idea about how he became so interested in birds or how he came to illustrate that seminal work on birds. Even in his own book on his birdwatching experiences, *The Birds of the Air*, he gives not a clue. Unlike

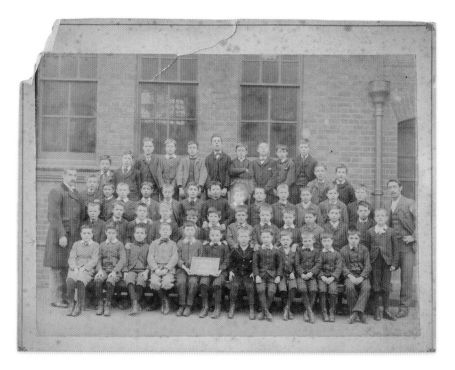

Central Boys School, Reading, 1892
Andrews, Headmaster, on the left; Allen Seaby,
Second Master, aged 25, on the right (GC)

Design for a Christmas card, 1895
Ink on board, 173×57mm
Given to Ada Taylor (then aged 24) by
Allen Seaby (28) three years before their
marriage in 1897 (GC)

Photograph of Seaby and his wife Ada
dated 26 August, 1902 (GC)

me, he was no hoarder of letters, or of all the accumulation of papers that can make life so rewarding for biographers. The few bits and pieces that do exist are tantalising because he knew and corresponded with many artists and leading figures of his day.

Allen William Seaby was born in London on 26 May 1867, the son of Augustin Seaby and Louisa, née Harrington. Augustin was a carpenter and cabinet-maker who suffered severely from asthma. He was advised to move from the fogs of Victorian London to the country and settled in the small Surrey town of Godalming in the early 1870s, and this is where Allen grew up. The countryside must have been a

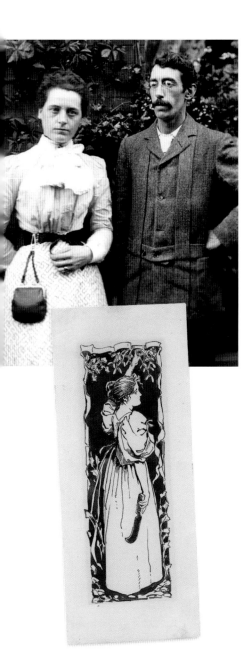

big influence on his later life and work, but sadly we know little of this time.

Allen's younger brother Frederick Arthur had died at the age of two; his father Augustin died in July 1880, when Allen was 13. Allen's mother, Louisa, carried on her business of dress-making in order to support herself and her son. From the age of 14 or 15, Allen was a pupil-teacher at Godalming Board School. He was clearly a bright lad and very fortunate in having a schoolmaster who took a great interest in his future and his already evident talent for drawing. He encouraged his pupil to qualify as a teacher and, as a result, Allen obtained a scholarship to the Borough Road Training College in Isleworth, where he studied from the age of 17 to 19. Isleworth was then part of rural Middlesex rather than Metropolitan London.

After qualifying in 1888, Seaby took up a position as an assistant council schoolteacher in Reading and taught in various schools, including Central Boys (which later became Katesgrove School) where he became Second Master in 1892 under Leonard Andrews.

He started to attend evening classes under W. Dawson Barkas at the Reading School of Art, which had been established in Valpy Street. Between 1892, when it was reconstituted as part of the University College, and 1895, he worked there as a student and sat various national examinations of the Department of Science and Art, always obtaining Excellent or First Class in each. In 1897 he married Ada Taylor and his first son, Herbert, was born the following year. In 1899, at the age of 32, he was invited to become a member of staff and eventually, in 1910, took over the headship of the Reading School of Art, which by then had moved to the University College campus on London Road.

He retired in 1933, having served longer than any other member of the University staff, and having known two Principals and two Vice-Chancellors.

☙

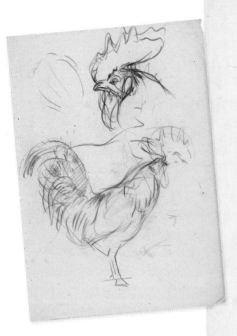

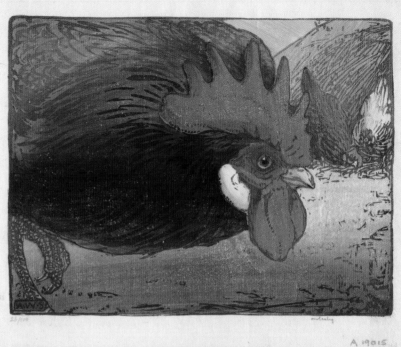

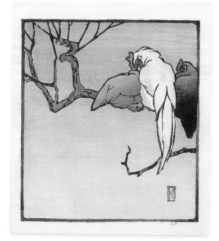

There is no doubt that he was adored by his students, and many kept in touch long after he had retired. In her autobiography *A Slender Reputation*, published as she approached her century in 1994, Kathleen Hale, creator of Orlando the Marmalade Cat, recalls Allen Seaby as

a wry old man, brittle with rheumatism, but as cheerful and alert as a bird. He was dedicated to traditional woodcuts, a laborious process which he insisted on teaching me. I worked extremely hard, and indeed was only turned out of the studio late in the evenings when it was time for the caretaker to lock up. Mr Seaby became a friend also, and after I had left Reading, I used to spend occasional weekends with him and his family.

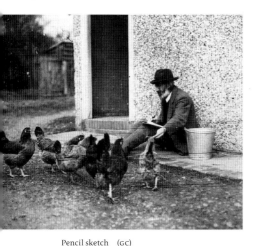

Pencil sketch (GC)

Crouching Cock, c. 1914
Colour woodcut, 150×200mm (GC)

Fowls (c. 1917) by Kathleen Hale
Colour woodcut, 160×145mm
From a portfolio of prints by staff and students
in the School of Art, University College, produced
as a limited edition for sale (T & GC)

Photograph of Seaby sketching hens, c. 1908 (GC)

Allen Seaby was a prolific writer: in the 20 years between his retirement and his death in 1953 he wrote or illustrated 25 books. He also wrote many articles, including some in *The Studio* magazine, and illustrated numerous books for other authors. His published work falls into four discrete categories: art books, natural history books, pony stories for young people, and historical romances. The books for which he is most famous are described in later sections but there are some unusual books that he illustrated for other authors which are worthy of mention here. F.B. Kirkman, the ornithologist and editor of *The British Bird Book*, produced a curious book entitled *Five Funny Fables and How to Play Them* in 1919, for which Seaby provided many two-colour illustrations. The use of a second colour was also notable in his drawings for *A Tale of Two Robins* by G.J. Renier, 1933. In 1948 he painted eight colour plates and made numerous line drawings for *Bird Stories for Little Folk*. I have Seaby's own copy of this book, but for some reason it was never published. Although it was produced by Wills and Hepworth, publishers of the Ladybird books, Seaby wondered if it had been privately printed, and even whether the name of the author, A. Windsor-Richards, could be the pen name of someone altogether more elevated.

A few years later, Seaby provided 48 paintings for two books in the Ladybird series *British Birds and their Nests*, written by the well-known naturalist and broadcaster Brian Vesey-Fitzgerald. Seaby was working on the last of these drawings shortly before his death on 28 July 1953. In a letter dated 12 June his senior editor at Ladybird thanks him for good wishes for his holiday and ends 'back on June 28th when I hope to see the drawings on my desk'. They were there, and following Seaby's death, the editor wrote to say that he had had no idea he had been dealing with a man in his eighty-sixth year. Seaby's mind and handwriting were vigorous to the end.

A unique feature of all his history books was the chapter at the end, where the teacher in Seaby was revealed. These chapters had titles

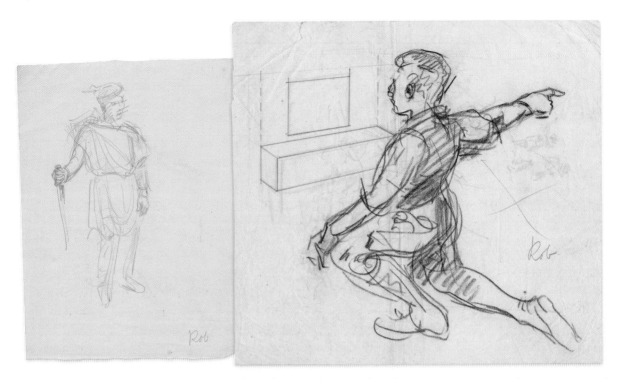

Pencil sketches of his grandson, Robert, modelling for one of the historical children's books, *c.* 1947 (GC)

such as 'Fact and Fiction' or 'History and Mystery'. In *Omrig and Nerla*, the final chapter was headed 'Any questions?' and the opening sentence reads, 'You may skip this chapter (and probably will do), for it contains nothing exciting, but I should like to think that some of you finished my tale with a number of questions you would wish to ask. So I have put down the answers beforehand.' I rather like the way he ends the chapter. After admitting that two well-known iron age camps may not have been present quite as early as suggested, he goes on to write, 'but I may point out that I have mentioned no dates, and can at least claim credit for being frank about it. After all this is not an archaeological treatise, but a romance, and I can only apologise to the archaeologists for liberties taken with their subject. However, those learned folk will probably never know that I have done so.' Another speciality of these books were the decorative maps on the endpapers that illustrated places and events in the story.

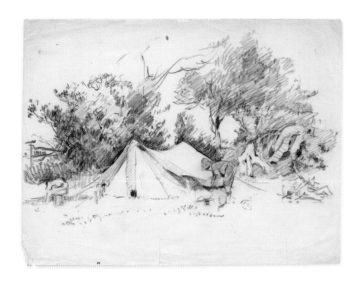

For all his books, where illustrations of people were required, Seaby would get friends, neighbours and family to pose – I was a model for illustrations in more than one of the historical books. The family holidays in the New Forest also provided Seaby with much material for picture making. They were pioneer campers and lived in improvised tents made by my grandmother. I have recently found some rather attractive little pen and ink drawings, evidently intended to accompany a piece on camping, but it was never published.

Camping in the New Forest, c. 1914–16
Pencil sketch, sheet size 210×279mm (GC)

Photograph of a camping holiday, *c.* 1914–16
Seaby (*left*), his youngest son Wilfred (*middle*)
and his wife Ada (*right*) (GC)

Peeling apples, c. 1914–16
Ink-drawn illustration of his daughter, Mildred,
for a book on camping that Seaby wrote but
never published (GC)

One of Seaby's interests lay in toys, especially wooden toys, and in making them. In 1916 he wrote an article in *The Studio* about hand-carved wooden toys from Germany and Eastern Europe. Before and during the first war he had carved his own toys, mostly animals, which he painted and varnished. They had heads that moved and glass eyes. Detail was added with a fine hot poker. Some were brightly coloured fantasy creatures designed as bath toys for young children.

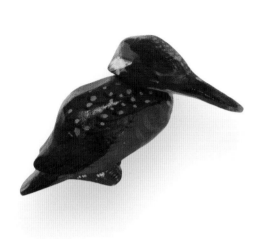

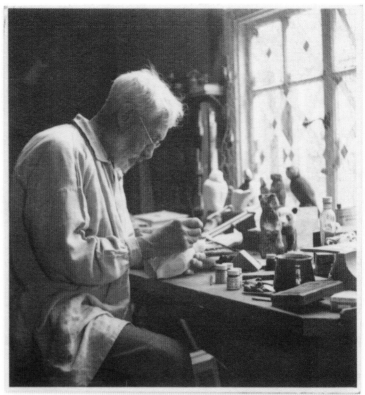

Wooden toy kingfisher, carved and painted by
Seaby, c.1940s
Height 100 mm (GC)
The article Seaby published in *The Studio* was
entitled 'Toys at the Whitechapel Art Gallery' and
was a review of an exhibition of toys from other parts
of Europe which was held in London in 1916 around
the time that an artist, Mr Vladimir Polunin, was
working with Seaby as artist in residence at the
University. *The Studio*, vol.68, no.281, August 1916,
pp.172–74.

Photograph of Seaby at his workbench painting
one of his carved wooden toys, taken by his grandson,
the late Peter Seaby, c.1940s. The window panes have
been crossed with brown tape as a precaution against
bomb blast. (T&GC)

The annual Seaby family holidays led him to discover the toy
factory in Brockenhurst run by a Frank Whittington who employed
local people to make his delightful animals. These were hand painted
by local girls whom Seaby sketched at work. In his book *Sons of
Skewbald* (1937) the heroine, Sally, makes wooden toy animals and
is clearly based on knowledge of the Whittington factory. Seaby's
animals are now treasured by those of us in the family lucky enough
to have them. I believe he used to sell them to American soldiers in
the second war, as a contribution to the war effort.

ৡ

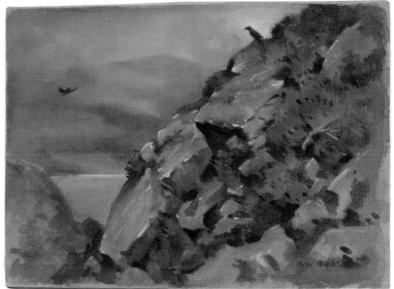

Farne Islands, the pinnacles at breeding time,
guillemots and kittiwakes, c. 1908
Oil sketch on board, 220×156mm (GC)

Raven Crag, North Wales, c. 1920s
Watercolour and gouache sketch on Holland linen,
254×356mm (GC)

As well as a prolific author and illustrator, Seaby was also a dedicated professional artist. Hundreds of sketches and studies were left in his studio after his death, many of which were shown in two studio exhibitions in 1998 and 1999. I derive as much, or more, pleasure from an artist's working drawings as from the finished work and these examples all seem pretty good to me.

He was a skilled oil painter, but I know of rather few gallery standard works in this medium. He did many small oil sketches outdoors on thin wooden panels, working in a typically British impressionist style. His handling of paint is delightfully free in places, but more controlled in depicting an excellent likeness, as in his portrait of Great Aunt Annie on page 53.

Seaby clearly did far more paintings in watercolour, sometimes in pure washes of colour; at other times, when working on linen, he would use body colour or gouache. The brown linen, called Holland, was introduced to him by Joseph Crawhall, one of the 'Glasgow Boys'

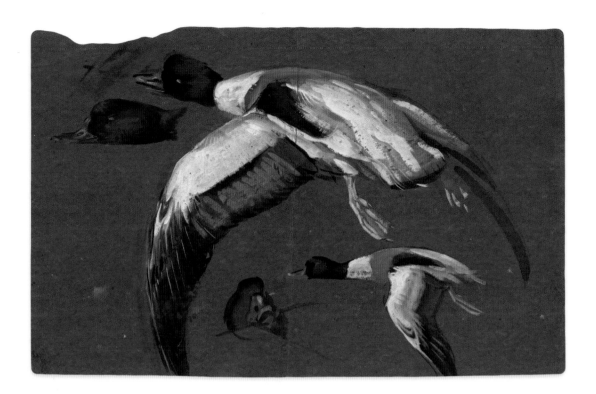

Shelduck with outstretched wing, c. 1900s
Watercolour and gouache sketch on heavy paper
normally used for carpet underlay, 365 × 575 mm
This drawing was one of many plumage studies
of freshly dead, as here, or stuffed birds. (GC)

and someone Seaby greatly admired. It was stretched on a frame, like a canvas for oil painting, and then dampened to make it taut. By working on the cloth when damp, Seaby achieved the misty or 'out of focus' backgrounds so typical of his work. As the linen dried he would paint in the detail and add highlights using Chinese white.

In Edinburgh, before World War I, he met the fine Scottish artist Edwin Alexander who introduced Seaby to another type of material: a thick, heavy textured paper used as an underlay for carpets and floor cloth. Seaby wrote that its merit was that it was very porous, allowing the colour to sink in. Also the grey tone gave one a head start, so to speak – the theory being that tones darker than that of the paper can be washed in transparently and highlights put in in body colour, or any tones lighter than the paper.

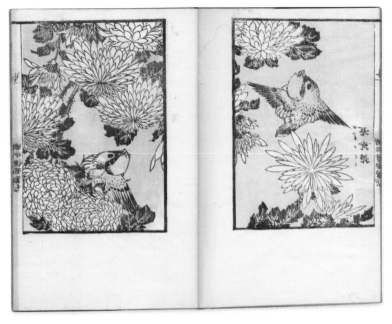

Illustration from a Japanese book of woodcut prints from Seaby's own collection, late nineteenth century Image size 109×156mm (GC)

But it is through the colour woodcut that Seaby's artistic view can be most clearly seen. He learnt the traditional Japanese techniques and employed them throughout his life. Like many artists of his time, and especially printmakers, he was influenced by the oriental approach, and he collected Japanese prints and books illustrated with woodcuts. But he soon developed his own style, which is immediately recognisable. His prints are mainly devoted to landscapes with or without human or animal involvement, and wildlife subjects, mainly birds but including mammals, fish, even insects. Over the years he made around 200 multi-colour woodcut prints, from small Christmas cards to large landscapes and wildlife studies. These prints were widely exhibited in the United Kingdom and abroad, including Paris, New York and Los Angeles.

He knew all the leading colour printmakers and was a founder member of the Society of Graver-Printers in Colour and the

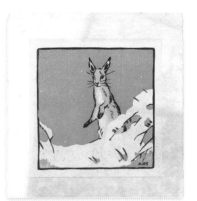

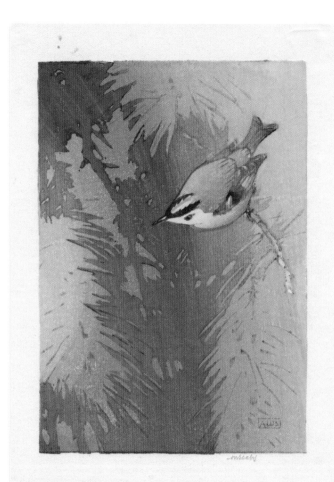

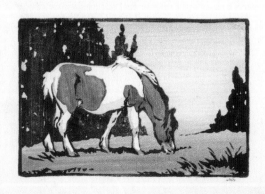

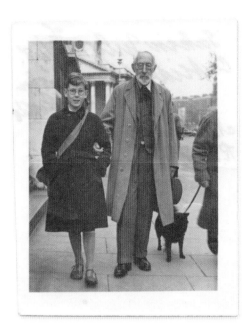

Selection of Christmas cards, colour woodcut prints: *Hare*, 82×82 mm, *c.* 1920; *Goldcrest*, 127×89 mm, *c.* 1938; *Christmas Roses*, 90×134 mm, *c.* 1930; *Pony*, 74×114 mm, 1925. This image was printed from lino and the print was advertised in Seaby's book *Colour Printing with Linoleum and Wood Blocks* as being on sale at a cost of 9*d*. (GC)

Photograph of Seaby with his grandson, Robert Gillmor, outside the National Gallery, July 1948 (GC)

Original Colour Print Society. He was also the co-founder, with Will Smallcombe, and first President of the Reading Guild of Artists in 1930. It continues to flourish more than 80 years later.

Despite the crash of the print market in the 1930s, Seaby continued to make prints for the rest of his life, producing an astonishing body of work. These are still popular, and in recent years his work has appeared among the cards marketed as the Museums and Galleries Collection, from prints held in the collection of the Scottish National Gallery of Modern Art in Edinburgh.

ॐ

How to sum up Seaby? For me he was a beloved grandfather who took me under his benevolent wing in my formative years. He had already retired before I was born so I only really got to know him when he was in his mid-seventies and I was eight, nine and ten and at primary school. He was very deaf but still active and involved to the end. I spent many hours in his studio – on the Shinfield Road in Reading, just past Crosfields School – watching him at work, studying his books and learning from him. He taught me the rudiments of oil painting; how to paint a glass. When, in July 1948, I won a national competition for beginners in oil painting, he took me to London to collect my prize. We were photographed by a street photographer outside the National Gallery where he had introduced me to some of the great masterpieces. I particularly remember how he got me to crouch down to see how the distorted skull in front of Holbein's painting 'The Ambassadors' snaps into shape when viewed along its length.

I don't think there is any doubt as to his qualities as a teacher. The closing words of the article about him in the magazine *Drawing and Design* (1924) were: 'Lucky indeed are those who are able to come under his personality as students of the College.'

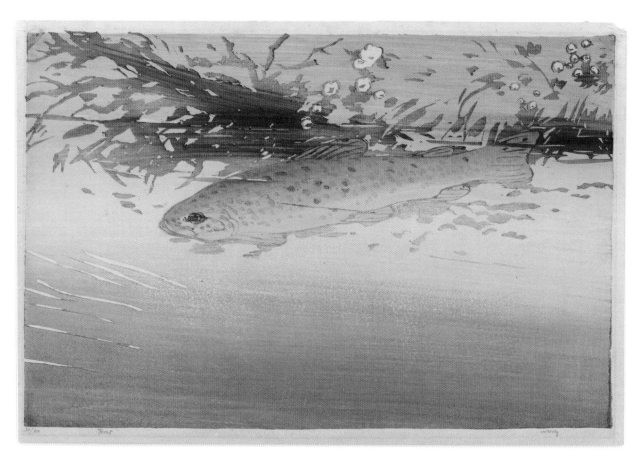

*Trout, c.*1920
Colour woodcut, 220×236mm (GC)

14

Artist and teacher

Martin Andrews

Allen Seaby was involved in art education in Reading for over 45 years. When he moved to the town in 1888 to take up a post as a schoolteacher, he became a regular attender of evening art classes at the School of Science and Art, which had been established in the 1860s and occupied premises in Valpy Street.

In 1892, the school's calendar lists Seaby as an assistant teacher; this was a significant year for the school as it became part of the Oxford Extension College movement which aimed to broaden fields of study and to 'bring education of a university type within reach of those who cannot go to the University'. A proportion of the classes were held in the evenings and on Saturdays to make them available to people like Seaby who were in full time employment. The Director and Headmaster at the time was the artist Dawson Barkas.

Courses were devised to be appropriate for training artists and art teachers but also for other trades and professions – classes were specifically aimed at masons, mechanics, builders, printers and architectural students. Initially, the emphasis was on developing drawing skills but as the school became increasingly associated with the Arts & Crafts movement it began to offer embroidery, wood-carving, printmaking and metalwork alongside the more traditional fine art subjects.

In 1895 Seaby was awarded an 'Art Master's Certificate', and in 1899 he was appointed as a full-time teacher in the Department of Fine Art. Walter Crane had been appointed as new Director the previous year, and Frank Morley Fletcher became a member of staff at the same time.

Then in his sixties, Crane was an artist and illustrator with an international reputation, a close colleague of William Morris and an influential figure in the Arts & Crafts movement and in art education. Crane had just completed a year as Principal of the Royal College of Art but had resigned because he felt it was too much of a commitment and distracted him from his work as an artist. He accepted the post of Director at Reading because he knew that he could rely on Morley Fletcher, who was appointed as Headmaster, to carry the burden of the day-to-day running of the Department. Years later Seaby wrote a short obituary of Crane whom he described as an 'old friend' of the Department and a 'writer, poet, artist, craftsman, and socialist'. Crane and a fellow artist, J.D. Batten, were influenced by the fascination for the Japanese aesthetic that was in vogue at the time. Both men had previously worked in a Pre-Raphaelite style. Batten had attended the School of Art in Reading in 1876 and later studied at the Slade under Legros. He returned to Reading to work with Crane and Morley Fletcher.

Morley Fletcher, younger than Crane by some 20 years, had studied in Paris for five years and while there had developed a passion for colour printing from woodblocks in the Japanese style. He had become a leading exponent of the process in Britain and since his return from Paris had been teaching these techniques at the Central School of Arts and Crafts in London.

Seaby, newly appointed to the staff, was thus contemporary with a number of notable artists of the time and fell under their influence, enthusiastically joining them in furthering the art of colour woodblock printing.

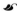

Seaby's post is described as 'Teacher of design' in the school calendar in 1899, but his duties were diverse: in 1900 he ran classes on 'drawing from the antique', 'modelling in clay from life', 'constructive

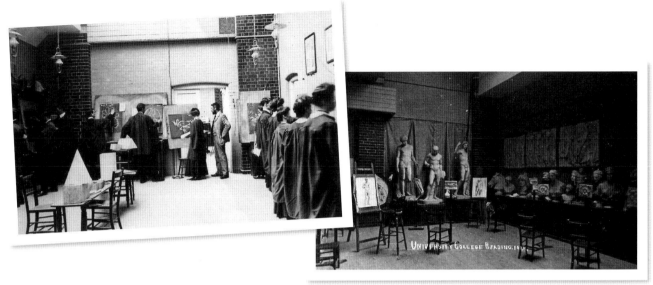

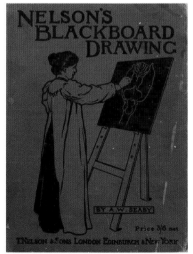

principles', 'historic styles' and 'design applied to crafts'. This last class was run under the close guidance of Crane and included designs for printing, book illustration, colour printing, gesso work, gilding, stained glass and embroidery. In 1903 'methods of class teaching' was added to his duties; this included techniques of 'blackboard drawing' and making diagrams as well as classroom teaching skills.

Morley Fletcher ran the class on 'woodcuts in colour' based on the 'Japanese practice'; when he left Reading in 1905 to become Director of the Edinburgh College of Art, Seaby took over his teaching. That same year the artist W.G Collingwood was appointed to the staff. Collingwood had been John Ruskin's valued assistant for many years but on Ruskin's death he turned to teaching. By 1907, Crane resigned as Director and Collingwood was appointed as the new Head. Crane continued his association with Reading by acting as external examiner, often assisted by Batten.

Allen Seaby teaching a class on blackboard drawing in the new studios at the London Road Campus, c.1906, and the cover of his book on the subject, first published in 1902 (Private collection)

Studio for drawing from the antique, 1910 (RUSC)

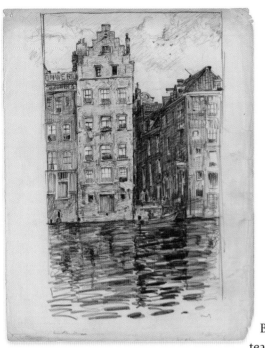

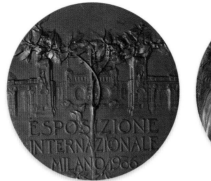

View of Amsterdam, 1911
Pencil and crayon sketch, sheet size 278×217mm
One of a number of views drawn while in Holland for
his 1911 exhibition in Amsterdam. (GC)

The medal awarded to Seaby and presented by
The British Commission at the International
Exhibition in Milan, 1906 (GC)

By the early 1900s Seaby was well established as an artist and teacher and was greatly appreciated by his students for his gentle but authoritative nature and skill as an educator. He had become a key member of staff, so much so that in 1911, when Collingwood resigned, Seaby himself was made Director. An announcement of his promotion appeared in *The Reading University College Review* in March 1911:

Mr Seaby, who has held the position of Lecturer in Fine Art, began his connexion with the College as a student. In 1899 he was appointed to the Staff, and in 1904 he obtained, after examination, the Associateship of University College, Reading, in Fine Art. In the following year he was elected an Associate of the International Society of Sculptors, Painters, and Gravers. Mr. Seaby's pictures and colour prints have been shown at exhibitions of this Society held in London, Munich, Dresden, Berlin, Milan, Vienna, Dublin, and elsewhere. He was awarded a gold medal at the Milan Exhibition of 1906. This medal was obtained for the distinction and merit of his colour prints executed according to the methods derived from

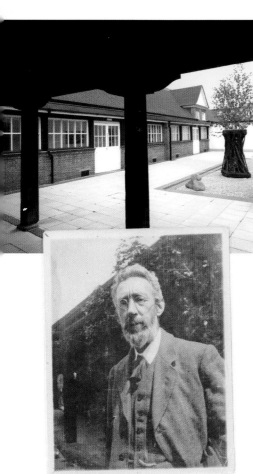

The buildings today (2014) once occupied by the Fine Art Department at the London Road Campus and now once again used by the Art Education Department of the University for teacher training

Professor Allen Seaby in front of one of the covered cloisters at the London Road Campus, c. 1930
(GC)

Japanese examples, and originally introduced into Reading by Mr. Morley Fletcher. In 1908 Mr. Seaby's (water)colours and colour prints were specially exhibited in Bond Street, and at the same date a set of his prints was acquired by the Victoria and Albert Museum. In 1910 he was elected a member of the Society of Graver-Printers in Colour, and his pictures have been shown at the exhibitions of this Society in London and Paris.... Early in the present year an exhibition of his water-colours and drawings was held in Amsterdam. Mr Seaby is a recognised authority on the teaching of drawing to school teachers, and his book on this subject is of standard merit. His appointment as Director of the Department of Fine Art has given much satisfaction to the very wide circle of friends who appreciate his talent as an artist and as a teacher.

As student numbers had increased, the college had moved to a new, purpose-built campus on the London Road in Reading in 1906. The layout was a central scheme of low red-brick buildings arranged around a large, open lawn and connected by timber-framed cloisters – modest but attractive architecture in the Arts & Crafts tradition. Here the Department of Fine Art flourished over the next 23 years under Seaby's direction.

As an author of books on the theory of art, natural history, history and children's fiction, Seaby found increasing success. Even so, and despite all the other calls on his energies, he also found time to contribute to the students' Art Club, founded in 1898; he gave talks, organised outings and exhibitions and invited speakers including Paul Nash, Eric Gill, Roger Fry and Stanley Spencer.

There were many eminent artists associated with the Department. When Crane retired from being external examiner in 1914, the role was filled for a short time by Professor W.R. Lethaby, followed by John Platt, another exponent of woodcutting in the Japanese style and strongly influenced by Morley Fletcher. Other artists associated with this form of printmaking included Sidney Lee and William

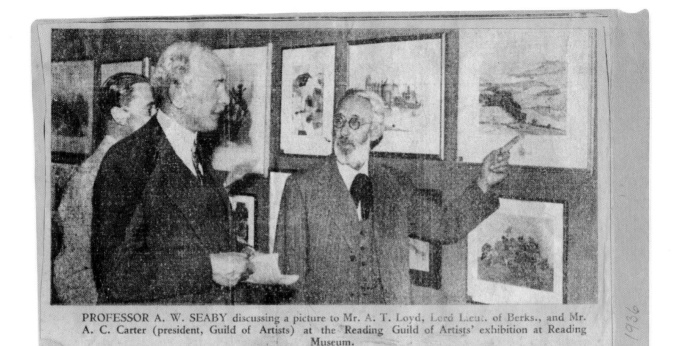

PROFESSOR A. W. SEABY discussing a picture to Mr. A. T. Loyd, Lord Lieut. of Berks., and Mr. A. C. Carter (president, Guild of Artists) at the Reading Guild of Artists' exhibition at Reading Museum.

1936

Giles, who became a close colleague. Born and brought up in Reading, Giles studied in Paris for a period but returned to Reading to work with Morley Fletcher during his tenure there.

Seaby took an active role in all aspects of University life. In 1920 he was made Professor of Fine Art and as a member of the Senate and other official committees, he championed the position that Fine Art should be taken seriously as an academic subject and not merely seen as a practical activity. Indeed, in 1915 he had written a passionate and well-argued plea for Fine Art to be recognised as a subject of 'proper university study leading to a degree' which finally became reality in 1936. He also fulfilled the social obligations of his position, hosting formal dinners and dances and promoting links outside the University, bringing together 'town and gown'.

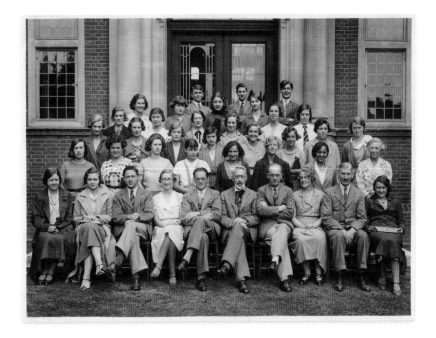

In 1930 he joined with William Smallcombe, Curator of Reading Museum and Art Gallery, in proposing the formation of an art society to be called the Reading Guild of Artists (RGA). The Guild still thrives today and over the decades has been a focus for the development of the arts in Reading. Seaby became the first President and exhibited regularly at the annual exhibition for the rest of his life. Most members of staff in Seaby's department played key roles in the Guild, alongside many notable local artists.

Several of the students of the School and later the Department of Fine Art had successful careers: E.S. Lumsden became a well-known etcher and printmaker and later, Kathleen Hale created Orlando the Marmalade Cat. Seaby was also surrounded by a supportive staff which included Cyril Pearce, Harold Yates and A.C. Carter, all distinguished artists in their own right. Seaby retired in 1933 and was given an Emeritus Professorship.

The Japanese woodcut process

Martin Andrews

A Japanese woodcutter at work
Image used on the front cover of *Colour Printing with Linoleum and Wood Blocks* (1925) by Seaby, published by Dryad Handicraft

The history of printing images in relief from woodblocks is a long one. It originates in the East: the oldest dated illustrated book to have survived is the *Diamond Sutra* from China, which was printed in 868 AD. Religious woodcut prints were published in Britain from the fourteenth century. In the East, blocks were printed using water-based inks, but in Europe oil-based inks were introduced in the fifteenth century, around the time of the development of the printing press.

In Britain by the nineteenth century, the woodcut – cut in relief along the grain of a plank of wood – was confined to low quality printed products such as posters, broadsheets and ballads. The more refined technique of wood-engraving – on blocks cut across the grain of the wood – was used primarily in better quality material. In contrast, in Japan the practice of printing from woodcut blocks had developed a distinctive aesthetic style. Its areas of flat colour and strong two-dimensional composition had a considerable influence on western art at the end of the nineteenth century.

In 1897, when Morley Fletcher began collaborating with J.D. Batten on experiments in woodcutting in the Japanese style, they based their ideas on an instruction pamphlet written by T. Tokumo that was published by the Smithsonian Institute in Washington in 1893. Batten had previously attempted to print from metal and woodblocks using colour pigments but had run into difficulties; having read Tokumo's pamphlet, he readily adopted the simpler Japanese methods. Batten and Fletcher also had the good fortune to meet a Japanese bookseller in London who, although not a printmaker himself, had some practical knowledge of the process that he passed on.

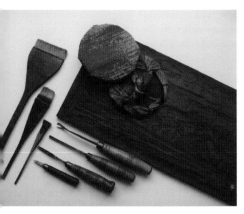

Selection of Seaby's own tools and a woodblock:
brushes, a knife, three gouges and two *barens*
(rubbing face and handle on reverse) (T&GC)

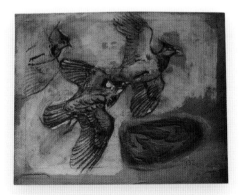

A block with one of Seaby's drawings of lapwings
pasted on the surface with the thickness of the
paper partly rubbed away before cutting
240×306mm (block size) (T&GC)

In Japan prints were made entirely by hand without the use of a press. All that was needed were some basic tools for cutting the designs into the surface of a plank of wood. Inks were water-based and applied with a brush, and the impression was taken by rubbing the back of the paper laid onto the inked block with a *baren*, a circular pad covered with bamboo leaf. Each part of the process was carried out by a different specialist craftsman – drawing the image, cutting the wood, planning the use of colour, preparing the inks and paper – and was organised on workshop principles for mass production. Batten and Morley Fletcher decided, however, that they would undertake all these tasks themselves as part of their individual artistic expression. Allen Seaby adopted their ideas and techniques and soon immersed himself in the medium. In time, the pioneering exponents of the technique – Morley Fletcher, Seaby, and later John Platt – all went on to produce instruction books on how to print from woodblocks. These helped to promote and spread interest in printmaking in the Japanese style, which became fashionable in the first half of the twentieth century.

The following brief description of the process is based on an article entitled 'Colour-Printing from Wood-blocks' written by Seaby and published in *The Studio* of 1919.

To begin with, the artist creates an outline drawing (the keyline) and decides on a number of areas of flat or gradated colour that will fit the keyline. To produce the keyline block from which all other blocks will be derived, a tracing on thin paper of the keyline drawing is pasted face down onto the woodblock. The block is preferably made of cherry wood, which is fairly soft to cut but tough enough to withstand hundreds of impressions being taken. The block, or plank, is cut to a thickness of no less than half an inch (15mm) and to dimensions larger than the image to provide a margin for registration marks, which are critical to the process and also cut into the block. To

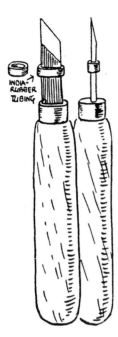

CUTTING-KNIFE

Line illustrations by Seaby of tools, reproduced in his article 'Colour-Printing from Wood-blocks', published in *The Studio* (1919)

The block and details of the printing surface used to print *The kingfisher* with residual colour still visible. The hand process allowed every area of a plank to be used (front and back) for the sake of economy which makes some of these images upside down. The blocks were also used for the small print of a goldcrest, illustrated on page 12. 310×250mm (block size) (T&GC)

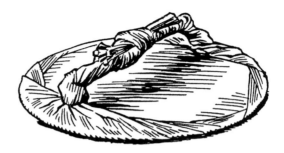

JAPANESE BAREN OR RUBBING PAD

ensure that the traced lines of the drawing are clearly visible, the tracing paper can be thinned by rubbing with fine sandpaper or made transparent with a dab of oil.

The artist uses a sharp knife to cut a V-shaped ditch either side of the drawn line. This slow and laborious process is followed by the cutting away of the larger areas of wood between the keylines using various gouges and a mallet, which leaves the lines that will print standing up in relief. Finally, the remaining fragments of tracing paper are removed.

The relief surfaces of the keyline block and registration marks are inked by brushing on fine Indian ink. To take a print, thin paper is placed flat onto the block and rubbed with a *baren*. (Although he does not mention it in his article, Seaby frequently put a protective sheet of tracing paper on top of the impression sheet before rubbing.) A sufficient number of prints are taken for the number of colours to be used in the final design; the artist then uses these to make the required blocks. Pasting the prints down as before, the artist uses the printed keyline as a guide to cutting away non-printing areas while ensuring that the edges of the colour areas will slightly overlap the outlines.

In preparation for printing the composite design, the paper has to be sized and dampened and the colour pigments chosen. Using the

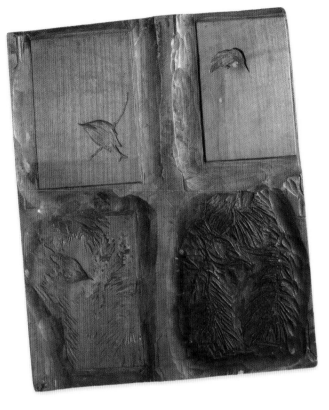

The kingfisher, c. 1920–30
Colour woodcut, 120×80 mm (RM)

Eight progressive proofs of *The kingfisher* showing the build-up of the image and colour (RM)

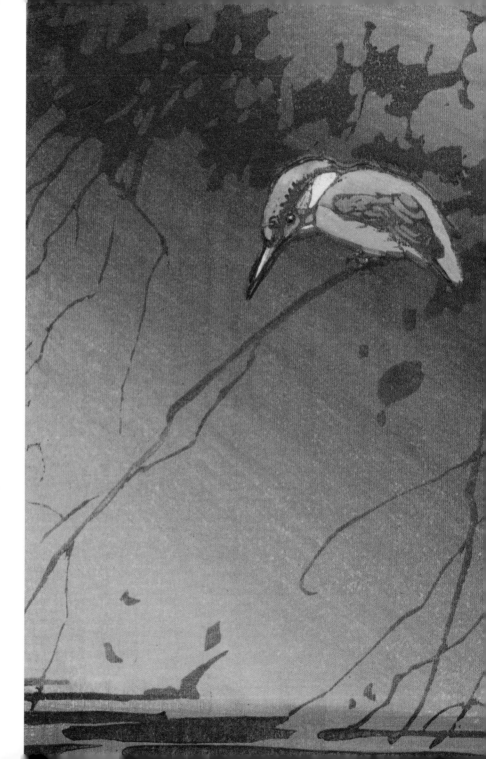

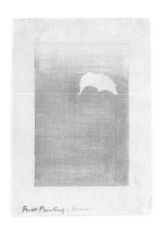

First Printing - Ground.

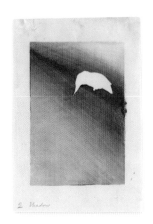

2 Shadow

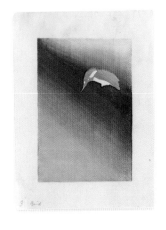

3 Bird

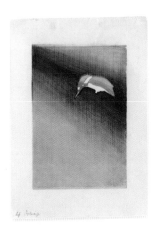

4 Scheme

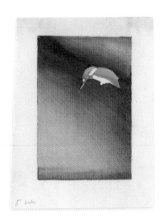

5 Water

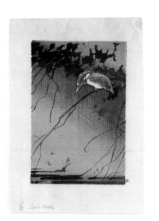

6 Dark Shade

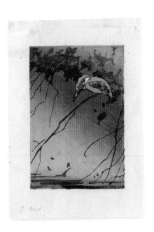

7 Bird.

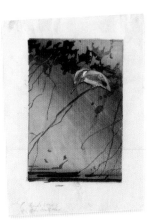

8 Bird

JAPANESE
BRUSH

Line illustrations by Seaby of tools and layout
of the printing table, reproduced in his article
'Colour-Printing from Wood-blocks', published
in *The Studio* (1919)

The dormouse, c. 1923 or earlier
Watercolour and pencil, 158×196 mm
The original colour sketch from which Seaby then
developed the woodcut print of the same subject
(GC)

The dormouse, c. 1923 or earlier
Colour woodcut, 152×188 mm (GC)

dampened paper, a batch of prints is taken from the keyline block.
Now the colours are over-printed one by one, starting with those with
the largest areas of colour. To ink the colour blocks, the artist mixes
small quantities of colour pigment with water to form a thin cream.
Having chosen an appropriately sized brush he dips it into the co-
lour, then into rice flour paste – used as a binding agent to aid adher-
ence to the paper – and proceeds to ink the relief areas of the block.
The sweep of the brush on large areas can create the most marvellous
and sensitive effects: the variable amount of colour in relation to the
paste and the brush marks and subtle gradation of tone and colour
blending that can be achieved by dipping one edge of the brush into
one colour and the other edge into another make each print a unique
work of art.

Accurate registration is critical: every sheet of paper is placed onto
the printing block in the correct position for each colour using the
registration marks. The finished prints are interleaved with dry
sheets and placed in a stack under pressure until they have dried flat.
(Seaby used a linen press for this purpose.)

Order and organisation are essential to achieve good results. The
working area has to be laid out with thought and care to keep things
to hand. The concentration and exacting skill required to make a suc-
cessful print is akin to an act of meditation.

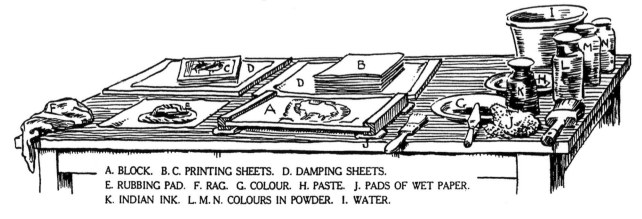

A. BLOCK. B. C. PRINTING SHEETS. D. DAMPING SHEETS.
E. RUBBING PAD. F. RAG. G. COLOUR. H. PASTE. J. PADS OF WET PAPER.
K. INDIAN INK. L. M. N. COLOURS IN POWDER. I. WATER.

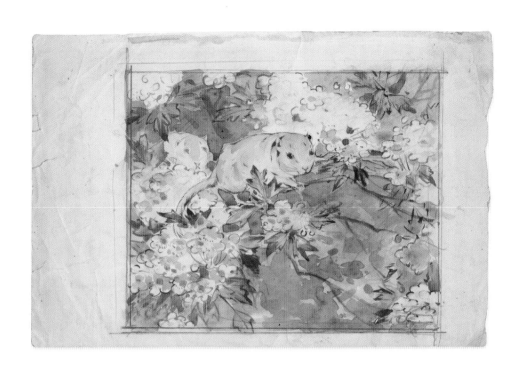

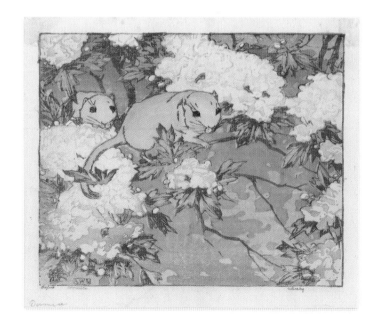

The colour woodcut movement

Martin Andrews

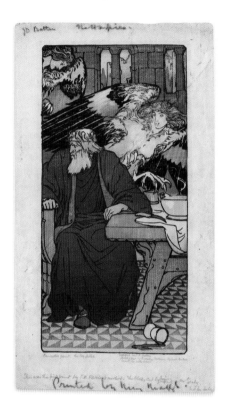

The harpies, 1894–5
J.D. Batten and Morley Fletcher
Colour woodcut, 308×150 mm
Claimed to be the first woodcut using water-
colour and Morley Fletcher's version of the
Japanese technique printed in Britain. Batten
and Morley Fletcher collaborated on the project:
Batten designed the image and Morley Fletcher
cut the blocks. This is a cancelled proof print
that belonged to Seaby, with his handwritten
notes. (GC)

The movement for woodblock colour printing in the Japanese style in which Seaby played such an important role came together at the beginning of the twentieth century from two strands: the aesthetic movement and the fashion for *Japonisme* championed by artists such as Whistler and Aubrey Beardsley, and the French impressionists and post-impressionists who were inspired by the colours and designs of woodcuts from Japan, in particular the stylised character of *Ukiyo-e* prints. Perhaps Walter Crane and Morley Fletcher can be said to represent these two strands.

From the 1870s, Crane's decorative style reflected his interest in Japanese art, stimulated by some colour prints he had been given by a Navy officer and friend who had visited Japan; however, Crane disapproved of the decadence of the aesthetic movement. Morley Fletcher had studied in Paris at the Atelier Cormon in the 1890s where he encountered Japanese printmaking and developed a passion for it. He brought back his new enthusiasm to England on his return; indeed, he put all his energies into spreading these ideas and became a pioneer of the medium among artists in Britain. In 1894–5, in collaboration with J.D. Batten, Morley Fletcher produced the first watercolour print from woodblocks in the Japanese spirit, but both men soon went on to make their own colour prints.

Morley Fletcher became the driving force for woodcut printing in the Japanese style, bringing together a group of artists working in the medium. Seaby was one of the first converts to and supporters of this fledgling movement. Another stimulus came in 1910, when a Japanese printmaker, Yoshijivo Urushibara, settled in Britain and worked with the artist Frank Brangwyn on woodcutting. He became an active member of the group.

The revival of old printing techniques and the introduction of new ones at the beginning of the twentieth century prompted the proliferation of specialist societies and clubs for mutual support among artists and opportunities to exhibit and promote their work. In 1907, Seaby became an Associate of the International Society of Sculptors, Painters and Gravers. Founded in 1898, the Society's first President was James Whistler, followed by Auguste Rodin. Many leading artists of the period were members of the Society, and Seaby regularly contributed to their exhibitions in Britain and abroad. Seaby was also a member of The Society of Graphic Art and The Society of Animal Painters.

Artists working with woodblocks soon formed factions: wood-engravers on the one hand, working in black and white with a focus on book illustration, and woodcutters on the other, producing colour prints as affordable art for the home. The Society of Wood Engravers and the Colour Woodcut Society were both established in 1920. There

was some rivalry but many artists had allegiances to both groups. Initiated by Morley Fletcher and Batten, the Colour Woodcut Society brought together a wide range of artists, including Seaby, and contributed greatly to the wider recognition of the medium by art critics and the public. The respected writers and critics Herbert Furst, Malcolm Salaman and Campbell Dodgson, Keeper of the Print Department at the British Museum, took up the cause and became enthusiastic supporters of the colour woodcut movement. They promoted the medium in numerous books and articles, particularly the art magazine *The Studio*. In *Modern Woodcuts and Lithographs*, published by The Studio Ltd in 1919, Salaman recognised the contribution of Morley Fletcher and Batten but also praised the role of Seaby:

> Mr. Allen W. Seaby... is, in his turn, exercising an important influence as teacher, inspiring with his enthusiasm and example a group of most promising students to expression through the wood-block colour-print. In his pictorial studies of bird life, Mr. Seaby accomplishes delightfully varied colour-harmonies, and his prints are among the most desirable of their kind.

Other artists featured in the book included members of a close circle of artists and friends who also made important contributions: Sidney Lee, William Giles and John Platt. Seaby also had friendships with Lady Miss Ethel Kirkpatrick and the Canadian printmaker Walter J. Phillips. The association with Reading of so many leading practitioners of printmaking in the Japanese style seems to have made it a nucleus for the movement.

In 1927, Seaby's woodcut 'Swans in Flight' appeared as the frontispiece in *The Woodcut of Today at Home and Abroad*, another Studio Ltd publication for which Salaman provided the commentary. He expressed his desire 'to see the Colour Woodcut Society join forces with the Society of Graver-Printers in Colour', though the differences between these organisations are not clear. Seaby was an active member

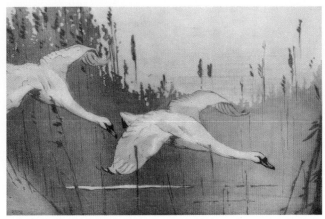

"SWANS IN FLIGHT" BY PROFESSOR ALLEN SEABY

of both but also helped to form The Colour Print Club, which had
developed out of the Society of Graver-Printers in Colour in 1909. In
1931 the Colour Print Club published the first issue of a short-lived
publication, the *Colour Print Club Journal*. William Giles was the
editor and Vice Presidents were Seaby, Sydney Lee, Giles himself
and Urushibara. Campbell Dodgson and Salaman were part of the
Reference Committee.

Seaby and Phillips also sat on the Council of another publication,
The Original Colour Print Magazine, of which William Giles was once
again the editor. This was a lavish and expensive production: each is-
sue was limited to 500 copies, with original prints tipped in. Founded
for the 'development and appreciation of the original colour print in
its widest sense', subscribers and contributors to the magazine au-
tomatically became members of the Original Colour Print Society.
Among the contributors was Claude Flight, more closely associated
with the linocut process and Grosvenor School of Modern Art, who

wrote an article and contributed a print in 1925. The issue of 1 June 1924 carried an article on Seaby's work, illustrated by a signed print of 'Blackcock and Greyhen'. The author, William Giles, was rather effusive in his praise:

> The brush-wash gradations of Seaby's prints have in them the music of the elusive, the gradations stand for more than tone and colour; it is an arrested moment of thought, with a dynamic break in sequence... . There is an attempt to express what man feels, rather than what he may momentarily see... it is the quality of "looseness" that is so characteristic of Seaby's prints Seaby's is a particular and pleasant phase of art and the world is the richer with every new interpretation of it.

Seaby, perhaps more so than his contemporaries, embodied in his woodcuts the spirit and dynamic composition of the Japanese print and fully exploited the texture of the brush stroke and blending of colour. Yet at the same time his work is quintessentially British, steeped in the countryside and wildlife of this island.

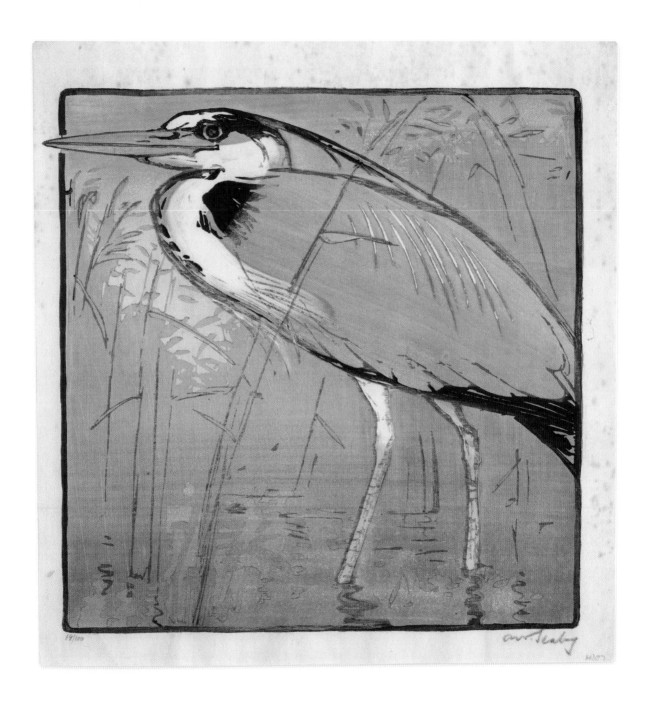

18/100 a/w Seaby

35

Author and illustrator

Martin Andrews

Illustration of figure drawing from *Drawing for Art Students and Illustrators* (1921)

Allen Seaby wrote and illustrated over 25 of his own books, wrote numerous articles and illustrated many books for other authors – a prolific output given his commitments to teaching and administration of a university department alongside his equally energetic career as an artist and printmaker. Many of his books achieved considerable popularity, were widely reviewed in the national press and frequently reprinted.

The subjects he wrote about reflected his own passions – art education, history and wildlife – but his readership was wide-ranging, from art students and teachers to naturalists of all ages, particularly children. For them he wrote works of fiction, often involving wild ponies, and historical novels which brought alive the past in the adventures of characters that children could relate to.

His first published work built on his experiences as a teacher and recognised the importance of visual aids in effective classroom teaching. *Nelson's Blackboard Drawing*, a 'how to' book based on the practical classes he taught in the Art School, was written and illustrated by Seaby and published by Thomas Nelson & Sons in 1902. It was reprinted frequently until 1909: full of informative illustrations, it became an early classic in the field. Further books aimed at art students followed. In 1921, the first edition of *Drawing for Art Students and Illustrators* was published by B.T. Batsford, and a second revised and enlarged edition followed in 1927. Many books covering similar subjects have been published but Seaby's sensitivity towards the needs of students stands out. His style is approachable and direct, covering theory as well as practice. His topics are conventional: proportion, tone, figure drawing and anatomy, animals, landscape. Copious

Two illustrations showing examples of drawings by Japanese masters reproduced in Japanese 'copy' books from the late nineteenth century that Seaby had collected and used in *Drawing for Art Students and Illustrators* (1921) (GC)

illustrations, both informative and instructional, fill the pages – his own and examples of student work – with frequent references to the drawing masters of the past. In his preface, Seaby refers to his own personal mentor: 'I must tender my acknowledgments to my master and friend, Mr. F. Morley Fletcher, to whom I owe everything in art, and especially for his teaching, as I understand it, of the use of expressive line'. In the introduction Seaby reveals his philosophy and approach to drawing, emphasising the value of drawing as a study. 'If the study has been made on right lines, if placing, proportion, movement and construction have been grappled with, the drawing has earned its place in the stairway of art study, for it has raised the student a step above his previous attempts'. He insists 'upon the importance of draughtsmanship in the classical sense' as understood by the great artists of the past – Holbein, Velasquez, Ingres and Degas – and that it must be acquired by 'severe training, and by intellectual visual effort. It must be searched for rather than picked up, and learned from one whom the student trusts'. But Seaby also looked to the East as well as European traditions, praising the 'calligraphic flow of line as seen in the Chinese and Japanese masters'. Batsford were well-established

Two illustrations from *Pattern without Pain* (1948), demonstrating Seaby's pleasure in colour and his fascination with design and pattern from the past

publishers on art subjects; in 1925 they produced Seaby's next book, *The Roman Alphabet and its Derivatives*. This book too was aimed at teachers, declaring that 'clear and legible forms must be taught'. Lettering and calligraphy had always been part of the curriculum in art schools, and the college at Reading had an additional interest in letterforms through the courses it ran for printing apprentices and type compositors in training. Following in the footsteps of Edward Johnson's influential book *Writing & Lettering, & Illuminating* (1906) Seaby gives an historical account of the development of the Roman alphabet and provides large-scale models of individual letters, based on the classical square capitals of Trajan's column, which are printed from woodblocks cut by Seaby himself.

In the same year, 1925, another company specialising in practical books on the arts and crafts, Dryad Handicrafts, published Seaby's *Colour Printing with Linoleum and Wood Blocks*, which explains his printing techniques for teachers and children in straightforward terms, advocating the use of simple subject matters and the joy of pattern. He later expanded on this subject in his last 'how to' book, *Pattern without Pain*, published in 1948 by Batsford.

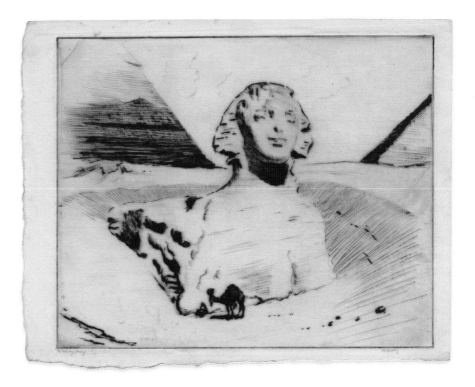

*Great Sphinx of Giza and the pyramids,
Egypt, c. 1925*
Etching and drypoint proof print,
plate size 200×250mm
Seaby only produced a small number
of etchings during his career; he preferred
relief printing. (GC)

In 1924 Seaby had been granted leave for a term to travel to the Mediterranean on a study tour exploring Greece, the Aegean, Egypt, and Italy. In 1928, his research came together in the first of an ambitious series of books published by Batsford, entitled *Art in the Life of Mankind*. The series was advertised as a 'concise but popular and informative series... designed to serve as an introduction to the Appreciation and study of Art in General and appeal to that wide public which has missed art in general education'. Seaby's self-motivated struggle to achieve an education in his own youth is reflected in this objective.

The first volume of the series was an introduction and 'General view of Art – its nature and meaning'. By 1931 Seaby had completed three further volumes focusing on the influence of the art and architecture

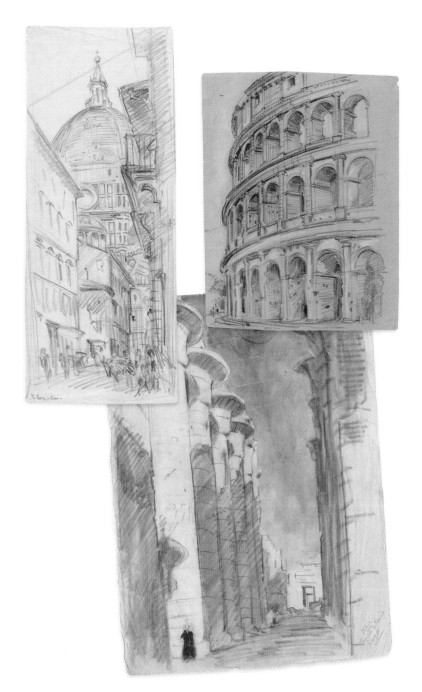

Drawings from the numerous sketchbooks Seaby
filled on his trip to the Mediterranean in 1924
(*left to right*): Florence; Colosseum, Rome; Venice;
Nave, Temple of Karnak, Luxor; Statue of Ramses II,
Luxor (GC)

Capital from the monument of Lysicrates and a bronze eagle from the Roman town of Silchester Ink-drawn illustrations from *Art in the Life of Mankind*, Part III: *Greek Art and its Influence* and Part IV: *Roman Art and its Influence* (1931)

of ancient Sumeria, Egypt, Babylonia, Assyria, and the Greek and Roman civilizations. The books were profusely illustrated with lively line drawings developed from the bulging sketchbooks that documented his travels. Some reviewers criticised the abundance (though not the quality) of ink drawings on the grounds that photographs would be more accurate and eliminate the interpretation of the object through the artist's marks and drawing style. However, Seaby strongly defended his use of sketches; he argued that they allowed him to focus on specific features and issues discussed in the text. Volume IV, *Roman Art and its Influence*, included a chapter on Roman Britain featuring the Roman town of Silchester, close to Reading. Seaby illustrated the chapter with the image of a bronze eagle which was found during the excavations and since then had been on permanent display in the Reading Museum & Art Gallery. Seaby's love of history and his friendship with the Director, William Smallcombe, prompted regular visits to the museum, and he had privileged access to the wealth of artefacts and treasures to be found within its walls.

Seaby's extensive knowledge of art history is revealed in the sheer volume of information amassed in these books, and readers could have been overwhelmed. Even though the writing may appear rather conventional and of its time to the modern reader, Seaby's style is concise, straightforward and engaging in its simplicity. Reviewers duly recognised that his writing was not aimed at academics and praised the book as 'a valuable preliminary to serious study'.

Seaby had complete control and mastery of the ink pen; his skill as a draughtsman enabled him to produce convincing and vigorous illustrations with speed and accuracy, although, like his writing, this documentary style is conventional rather than inspired.

Further volumes of the series *Art in the Life of Mankind* were planned but never completed, but some years later Seaby channelled his knowledge of archaeology and history into a number of books of historical reconstructions for children – essentially adventure stories

"Yes," said Dick, and added proudly, "Father says I shall make a good charcoal-burner if I go on as I've begun. Next week I am to work full time."

"Well done, little man. And where have you been today?"

"In the forest beyond Malwood. My sister and I have been gathering fire wood."

Ink drawing and typescript marked up with corrections and instructions to the printer for *Purkess the Charcoal Burner* (1946) (T & GC)

Cover of *Sheltie: The Story of a Shetland Pony* (1939)

The old mare and her foal
Pencil-drawn illustration from *British Ponies: Running wild and ridden* (1936)

Sketches of deer in the New Forest from one of Seaby's numerous sketchbooks filled during family holidays (GC)

Press-cutting from the *Spectator* 26 September 1936

with young children as central figures. Seaby packed his fiction with period detail. Titles such as *The Ninth Legion* (1943) might well have been an inspiration for Rosemary Sutcliff's *Eagle of the Ninth* (1954) which features the bronze eagle from Silchester. *Purkess the Charcoal Burner* (1946), *Alfred's Jewel* (1947) and *Blondel the Minstrel* (1951), published by George G. Harrap & Co. Ltd, were all successful titles. However, his very first historical tale was published in 1934, the year after he retired from the University. *Omrig and Nerla* was a story about wild ponies set in the Bronze Age – and it is probably as an author of books about ponies that Seaby is best known.

Passionate about the preservation of Britain's native wild breeds of ponies, Seaby wrote five storybooks with ponies at the centre of the narrative and numerous articles on the subject. In the 1920s, he bought a plot of land in Tiptoe, near Sway, in Hampshire's New Forest, and built a simple hut surrounded by common grazing ground. It was a holiday home for the family but also a base for Seaby to observe and explore wildlife, ponies in particular, and set out on camping adventures. In 1923, A. & C. Black published *Skewbald: The New Forest Pony* to unanimous praise in the press; more than 18,000 copies were sold. The success of this book spawned a whole series of pony books, and Seaby travelled from Dartmoor to Shetland via Wales to study and draw the local breeds. Seaby felt that these breeds were under threat and advocated their use as ponies for riding in the hope that they could be sustained. In 1936 he wrote *British Ponies, Running Wild and Ridden,* with beautiful illustrations in pencil and ink that wonderfully capture the life and movement of these sensitive creatures.

In a review of *British Ponies* in the *Spectator* the reviewer commented that Seaby should do 'like service for British deer' and in 1939, Seaby rose to the challenge and published a story entitled *The White Buck* set in the New Forest. Later that year he sent a copy to Walt Disney Productions. A story editor there expressed enjoyment of the book but in his reply regretted that they could not consider it

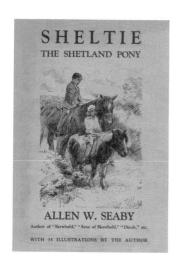

SHELTIE
THE SHETLAND PONY

ALLEN W. SEABY
Author of "Skewbald," "Sons of Skewbald," "Dinah," etc.

WITH 35 ILLUSTRATIONS BY THE AUTHOR

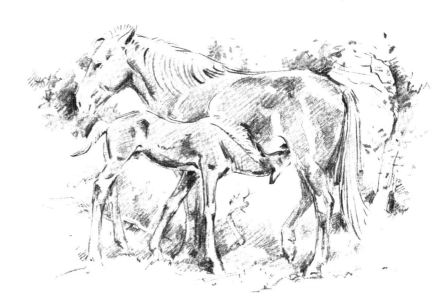

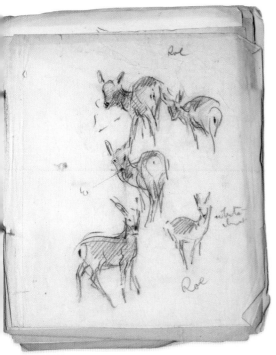

An Artist's View

It is a welcome sign of the revival of the pony that Mr. Seaby has turned his attention from the biped to the quadruped. He is among the best of our naturalists, has seen with his own eyes every species of our birds in its native haunt, and drawn them all with truth and vivacity. The eye that can catch the turn of the wing in a dipping woodcock has proved as keen in indicating the paces of a Welsh pony. He has followed the example of Mr. Lowes Luard who spent years in analysing the paces of a horse before he wrote his really classic thesis on the subject. Mr. Seaby's book, *British Ponies* (A. and C. Black, 12s. 6d.) is a triumph not of science but of art, and the children are as charming as the ponies, when he depicts the ridden and not the wild animal. May I suggest

that he does a like service for British deer, which have been much neglected, and the so-called wild or primitive types of cattle might be included? We have so few large mammals in this island that we should make the most of those we have. A successor to J. G. Millais is much wanted.

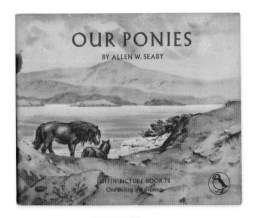

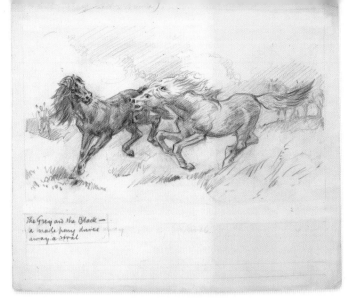

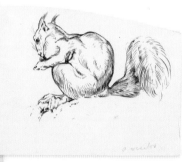

Cover of *Our Ponies* (1949), Puffin Picture Book 78

The Grey and the Black – a male pony drives away a rival, c. 1949
Pencil-drawn artwork for *Our Ponies* (1949), Puffin Picture Book 78
This illustration was not included in the book as it was considered rather violent. (GC)

Ink drawings of a red squirrel and a long-eared bat (unpublished) and of a toad from *The English Year: Spring*, published by T.C. & E.C. Jack (1914)

for a film: as they were already 'making an adaptation of Felix Salten's *Bambi*, it seems inadvisable for us to include another deer story in our current production schedule' – an unfortunate coincidence for Seaby.

In very condensed form, Seaby pursued the pony theme in a book commissioned by Noel Carrington for his series of Puffin Picture Books: *Our Ponies* came out in 1949 and was again illustrated by reproductions of soft pencil drawings. Seaby also submitted a draft of a book to teach children drawing for the same series, but this was never published.

The bird artist

Robert Gillmor

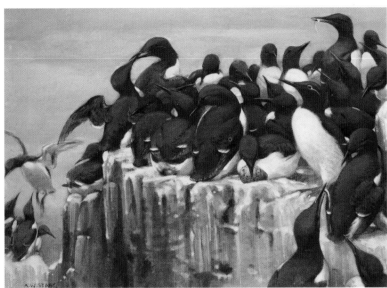

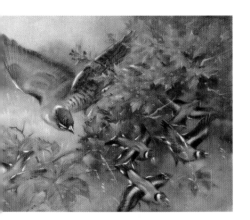

A charm of goldfinches disturbed by a sparrow-hawk, c. 1910
Watercolour and gouache on linen, 350×480 mm
(RM/1953.145.1)

Guillemots, 1910
Watercolour and gouache on linen, 280×350 mm
Illustration from *The British Bird Book*
(RM/1963.242.1)

In his woodcut prints Allen Seaby made an original, individual and significant contribution to art, but undoubtedly it is in his depiction of wildlife, and birds in particular, that Seaby's skill and vision as an artist can be observed best. He is most widely known for his bird paintings, particularly the 135 plates he, amongst other artists, contributed to *The British Bird Book: An account of all the birds, nests and eggs found in the British Isles*, edited by the leading ornithologist F.B. Kirkman, a major and innovative work published in 12 parts between 1910 and 1913. All the plates were later reprinted in a single volume by Kirkman and F.C.R. Jourdain, first published in 1930 and reprinted

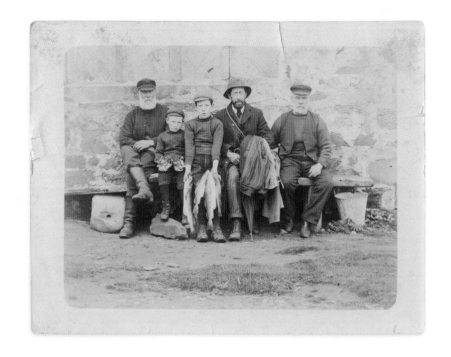

Photograph taken by the ornithologist F.B. Kirkman of Seaby, surrounded by local fishermen on the Farne Islands. Scribbled on the reverse is a note saying they were grand-nephews of Grace Darling. Seaby accompanied Kirkman on a one-week trip to the islands in 1910 during the preparation of *The British Bird Book* and made copious drawn and written notes. The painting *Guillemots* on page 45 was certainly conceived on this visit. (GC)

many times. A number of Seaby's plates from the book were also used in several other books by different authors.

To gather information and inspiration for his plates, Seaby travelled widely around Britain – as far as Shetland, where he sketched a whimbrel driving a raven from its breeding ground – but also made use of observations closer to home: in his own garden, the University campus in Reading and the Berkshire countryside. He captured starlings quarrelling on the lawn in front of the Senior Common Room; the snowy backdrop to migrating redwings is the rolling upland of the Berkshire Downs.

In 1922, Seaby provided small pen and ink illustrations for another book written by Kirkman entitled *British Birds*, which was published in many revised and updated editions until 1933. The well-known artist, author and broadcaster on bird life, Eric Ennion, recommended it and commented on 'Seaby's exquisite line sketches'.

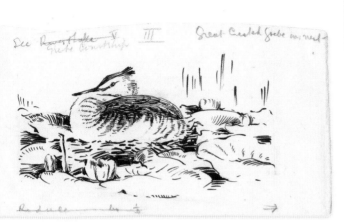

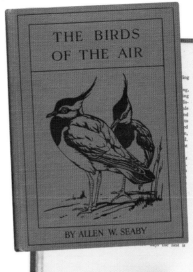

Great crested grebe on nest, 1931
Ink-drawn artwork used as an illustration for
The Birds of the Air (1931), sheet size 98×181mm
(GC)

Cover of *The Birds of the Air*, 1932

Wood-wren and *Goldcrest*
Pen and ink illustrations from *The Birds of the Air*
by Seaby, 1931

Seaby later wrote and illustrated his own book, *The Birds of the Air* (1931), recounting in a very personal and engaging way his experiences and observations while on his travels and at home. Published by A. & C. Black, it was illustrated with 134 pen and ink drawings, mostly based on the visual notes he had made in his numerous sketchbooks.

Looking through the sketchbooks one comes across the source for many of the paintings in Kirkman and, occasionally, actual composition ideas for particular plates. For the information he needed on plumage pattern and colour he made large numbers of careful colour studies of dead birds, of prepared skins found in museum trays, and even stuffed birds. The latter were always crossed through with a pencil line as he would not trust the pose of a stuffed bird, preferring his own notes, however sketchy, done from life. In the field he had a simple pair of field glasses and often worked in small sketchbooks, no larger than a postcard. These are filled with notes on birds, the places where they were found, the addresses of acquaintances made while travelling, and *aides-memoires* of all kinds.

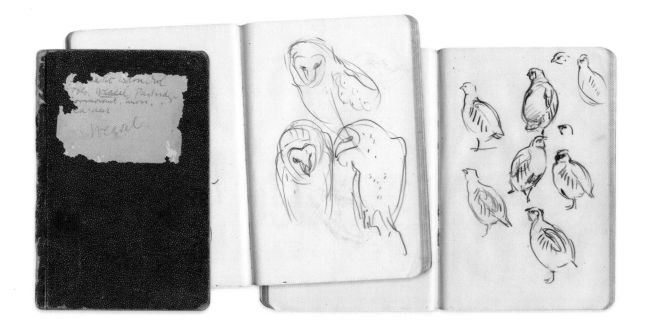

Pages from two of Seaby's sketchbooks
with drawings of barn owls and partridges,
page size 176×121mm (GC)

Examples of watercolour and gouache sketches
and drawings; studies of plumage taken from
dead or stuffed specimens or skins:
Study of a wing, sheet size 405×278mm; study
of a foreign woodpecker and female stonechat
and others, sheet size 390×293mm (GC)

Many of his sketches were drawn at high speed, capturing what I would call the 'jizz' of his subjects. Whilst they would seldom convey the detailed representation of the bird as found in the paintings, they contain Seaby's reaction to the bird, the impression of its movements and ways of standing, feeding or flying. With his studies of dead birds and skins and the sketches, so full of life and vitality, he made pictures that had a truth to life missing from the work of some of his contemporaries.

Seaby appreciated and respected the work of other artists in the field. The influence of oriental art and particularly that of Japan is strong, but he was also aware of the work of the eminent Swedish wildlife artist Bruno Liljefors long before he became well known in this country. Seaby knew or corresponded with several of his contemporaries, including George Lodge, Edwin Alexander and Joseph Crawhall, whom he greatly admired.

From the Lodge's Collection

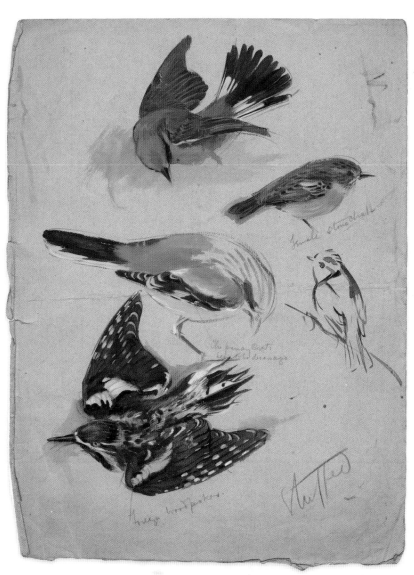

49

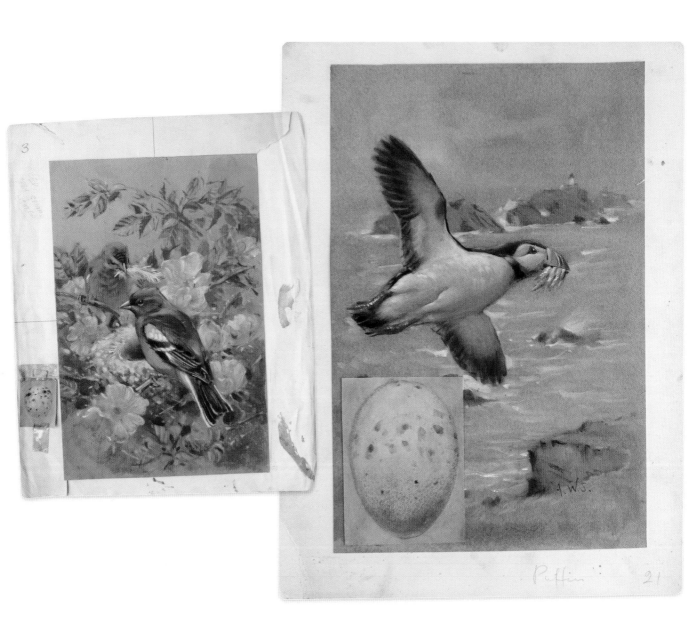

3

Puffin 21

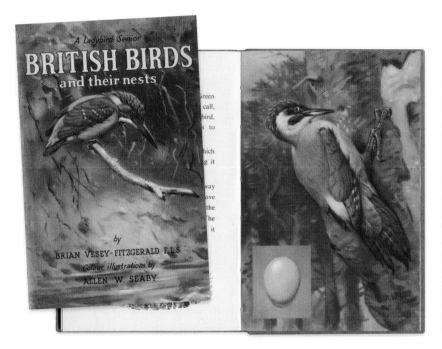

Facing page:
Artwork for *A Second Book of British Birds and their Nests* (1954) *The chaffinch* and *The puffin* Watercolour and gouache, chaffinch: 265×176 mm; puffin: 265×176 mm (RUSC)

Covers and a page showing a green woodpecker from *British Birds and their Nests* (1953) and *A Second Book of British Birds and their Nests* (1954) (GC)

There was a long interval before Seaby illustrated another bird book, and this was to be a considerable contrast to the one published over 40 years earlier. He was approached by Wills and Hepworth to paint the illustrations for a book on birds in their now famous Ladybird series, *British Birds and their Nests,* published in 1953. The author was Brian Vesey-Fitzgerald, a radio broadcaster and writer on natural history and country life.

A number of the plates for the Ladybird book hark back to Seaby's paintings for Kirkman, making use of sketches and studies he had done during the first decade of the twentieth century. On the cover of the book is a kingfisher perched above a stream, looking intently into the water prior to diving down. This recalls woodcuts of a kingfisher made many years before (page 26).

As a small boy I often went with my grandfather on walks near his home; I would describe the bird sounds, which he could no longer hear, and he told me about the birds that made them. We usually walked past the old barn that he used as a background for the Ladybird plate of the house martins collecting mud for their nests. The background to the picture of a black-headed gull shows the Needles off the Isle of Wight, a scene he painted many times during the family's annual summer holidays camping in the New Forest. When he was working on *A Second Book of British Birds and their Nests* for the Ladybird series – finally published in 1954, the year after his death – I found myself helping him. He was having trouble with the painting of a puffin in flight. I had recently returned from a trip to Skokholm with a birding group from school, and had made my own sketches as puffins whirred past the clifftop where I sat. We used these drawings to try to get the bird right. Sometime later I had a wonderful letter from him, the last I would receive. He always signed his letters in full – never 'Grandpa'. He started to rough out the ideas for a third book but died before he could make a serious start.

Seaby's obituary in *The Times* (30 July 1953) paid tribute above all to his ability to synthesise art and nature: his 'studies of wildlife', the writer noted, are significant for the way in which 'naturalistic truth is combined with decorative disposition'. Seaby's work bridges 'the gap between fine art and so called "wildlife art"'.

Gallery of Seaby's work

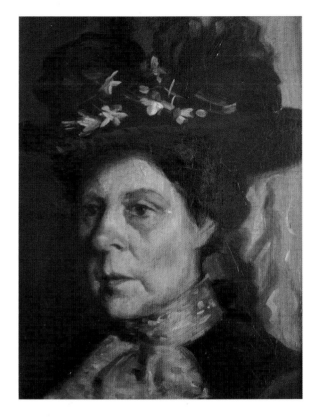

Great Aunt Annie, c. 1900
Oil on canvas, 340×440mm (GC)

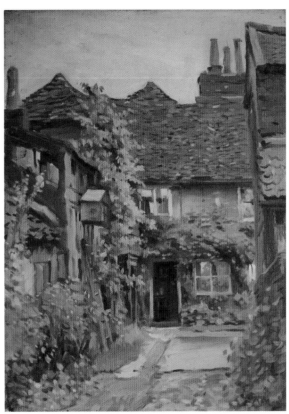

Steeple Place, Reading, c. 1933
Oil on canvas, 350×250mm (RM/1934.7.1)

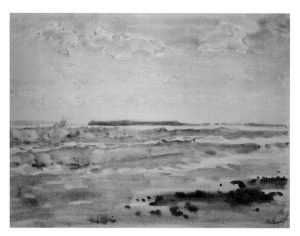

Seascape, 1920s
Watercolour, 260×360mm (GC)

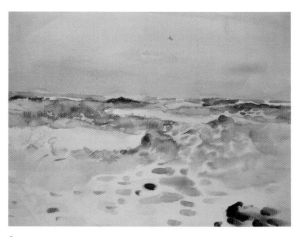

Seascape, 1920s
Watercolour, 250×350mm (GC)

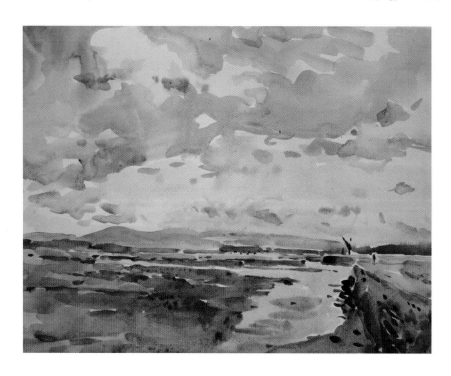

Norfolk, 1920s
Watercolour, 250×330mm (GC)

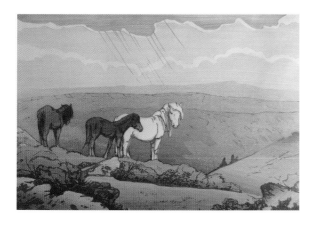

Dartmoor ponies, 1930s
Colour woodcut, 215×325mm　(RM/1937.58.1)

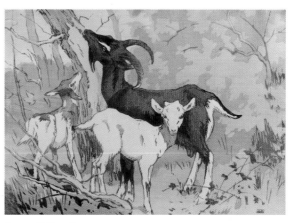

Goats and kids, early 1930s
Colour woodcut, 220×310mm　(RM/1949.19.1)

Red squirrel, 1930s
Colour woodcut, 200×260mm　(RM/1953.151.1)

Happy family, 1921
Colour woodcut, 210×290mm　(RM/1949.24.1)

Hare in snow, 1923
Colour woodcut, 225×320 mm (RM/1949.27.1)

Harlech Castle, early 1930s
Colour woodcut, 225×330mm (RM/1953.190.1)

Valley of the Kings, Egypt, early 1920s
Colour woodcut, 235×310mm (RM/1953.185.1)

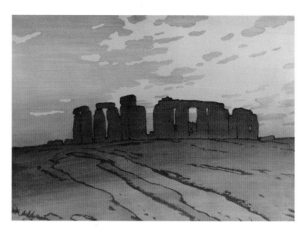

Stonehenge, early 1930s
Colour woodcut, 225×325mm (RM/1935.10.2)

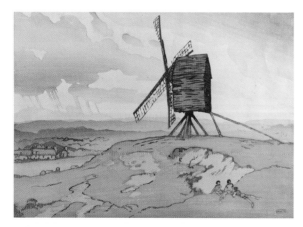

Brill windmill, 1940s
Colour woodcut, 225×320mm (RM/1953.152.1)

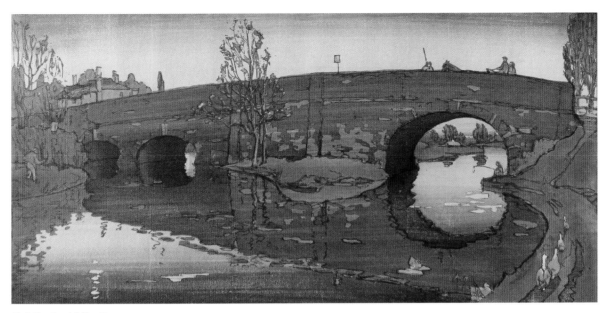

The bridge, Burghfield, mid 1900s
Colour woodcut, 205×405mm (RM/1931.204.1)

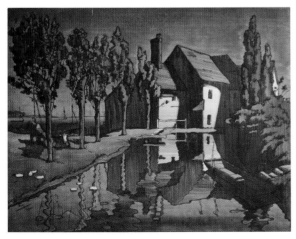

Bosham Mill by moonlight, mid 1900s
Colour woodcut, 305×400mm (RM/1931.202.1)

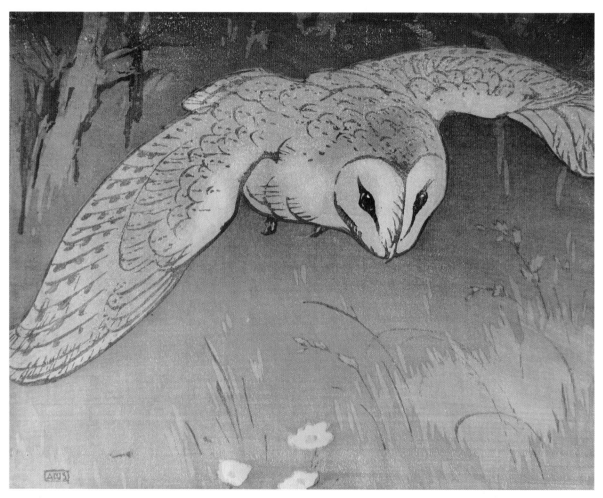

Barn owl, 1940s
Colour woodcut, 205×260mm (RM/1949.18.1)

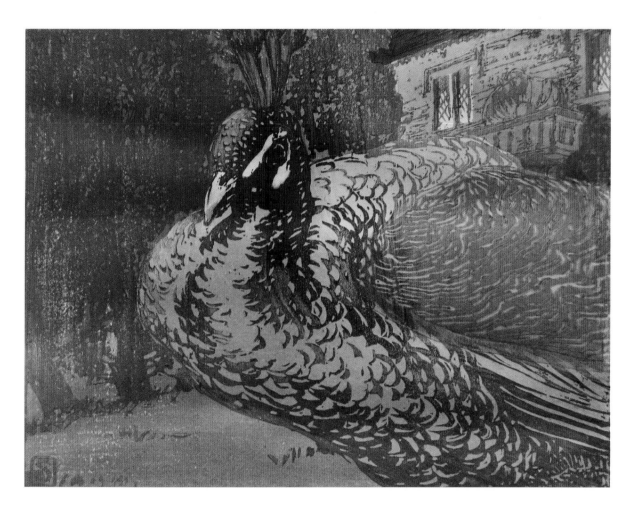

Peacock, 1908
Colour woodcut, 160×210mm (RM/1931.200.1)

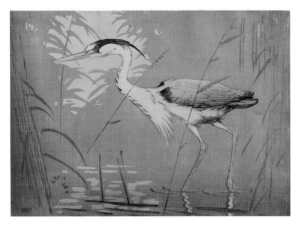

Heron, 1930s
Colour woodcut, 240×345 mm (RM/1949.106.1)

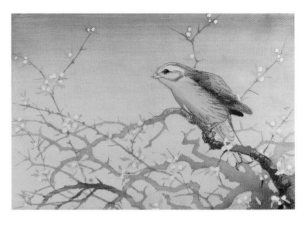

Yellowhammer, early 1930s
Colour woodcut, 210×305 mm (RM/1935.9.1)

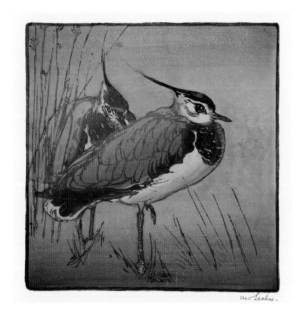

Lapwings, 1905
Colour woodcut, 220×215 mm (RM/1931.198.1)

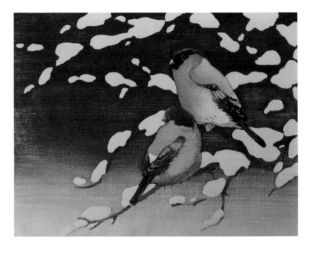

Bullfinches on snow covered branch, c.1911
Colour woodcut, 195×256 mm (Private collection)

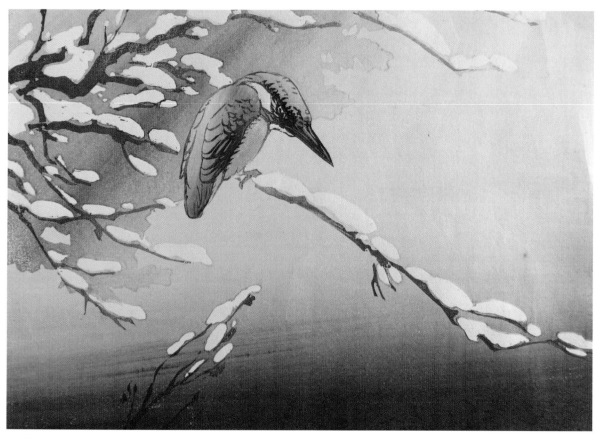

Kingfisher on snow covered branch, 1930s
Colour woodcut, 160×227mm (RM/2001.135.1)

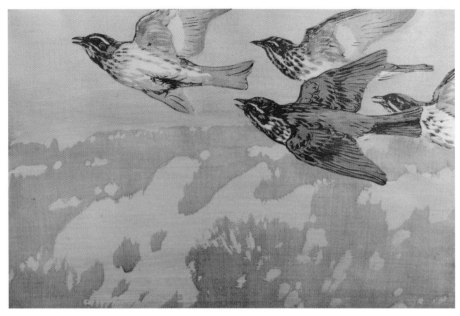

Redwings in flight over the Berkshire Downs, early 1920s
Colour woodcut, 220×344 mm (RM/1928.229.5)

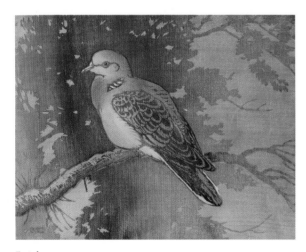

Turtedove, 1930s
Colour woodcut, 203×258 mm (RM/1953.189.1)

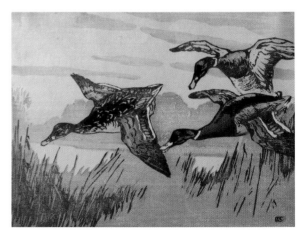

Mallards in flight, 1930s
Colour woodcut, 190×260 mm (RM/1953.146.1)

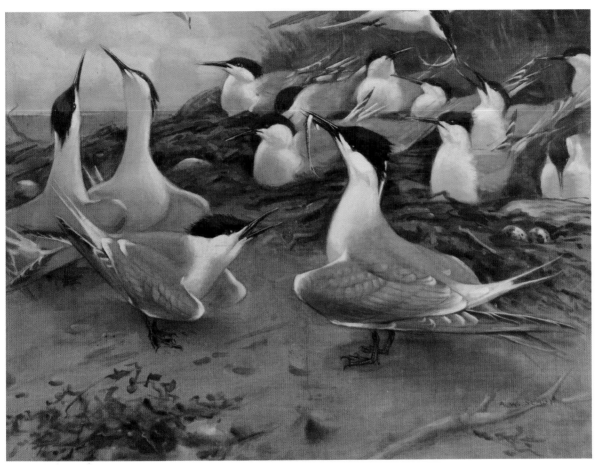

Sandwich terns, c. 1910
Watercolour with gouache on linen over card, 365×490mm
Illustration from *The British Bird Book* (RM/1963.239.1)

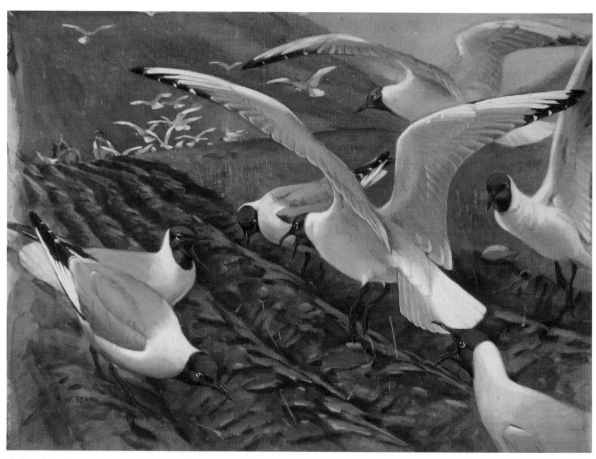

*Black-headed gulls, c.*1910
Watercolour with gouache on linen over card, 510×680mm
Illustration from *The British Bird Book* (RM/1963.243.1)

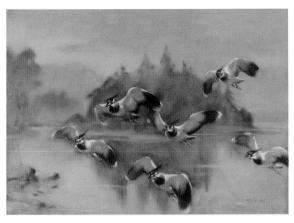

Peewits, Loch Inch, 1950s
Watercolour with gouache on linen over card, 405×560mm (RM/1952.62.1)

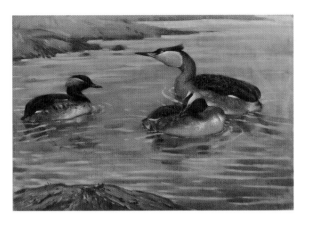

Red-necked grebe (largest), Black-necked (left) and Slavonian grebe, c.1910
Watercolour with gouache on linen over card, 350×490mm
Illustration from *The British Bird Book* (RM/1963.242.1)

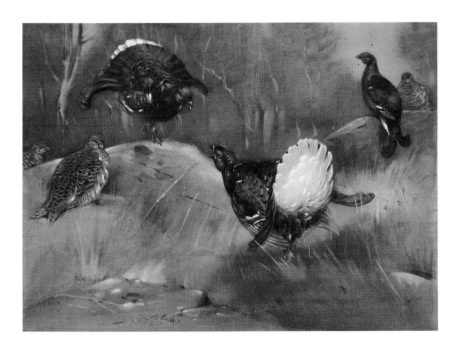

Black grouse at the lek, c.1910
Watercolour with gouache on linen over
card, 500×695mm
Illustration from *The British Bird Book*
(RM/1963.240.1)

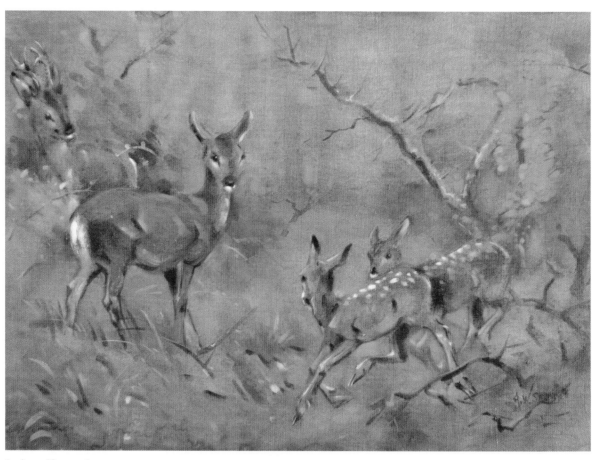

Roe deer and fawns, early 1950s
Watercolour with gouache on linen over card, 270×386mm (RM/1953.143.1)

New Forest, after the show, c. 1949
Watercolour with gouache on linen over card, 300×405mm
Illustration from the back cover of *Our ponies*, see page 44 (RM/1953.141.1)

Allen Seaby: a bibliography

(1904) *Nelson's Blackboard Drawing*. London: Thomas Nelson & Sons

(1921) *Drawing for Art Students and Illustrators*. London: B.T. Batsford

(1923) *Skewbald: The New Forest pony*. London: A. & C. Black

(1925) *Colour Printing with Linoleum and Wood Blocks*. Leicester: Dryad Handicrafts

(1925) *The Roman Alphabet and its Derivatives*. London: B.T. Batsford

(1928) *Art in the Life of Mankind*, Volume I: *A Survey of its Achievements from the Earliest Times*. London: B.T. Batsford

(1928) *Art in the Life of Mankind*, Volume II: *Art in Ancient Times – Prehistoric, Sumerian, Egyptian, Babylonian, Assyrian & Aegean*. London: B.T. Batsford

(1928) *Exmoor Lass and Other Pony Stories*. London: A. & C. Black

(1931) *Art in the Life of Mankind*, Volume III: *Greek Art and its Influence*. London: B.T. Batsford

(1931) *Art in the Life of Mankind*, Volume IV: *Roman Art and its Influence*. London: B.T. Batsford

(1931) *The Birds of the Air*. London: A. & C. Black

(1934) *Omrig and Nerla*. London: George G. Harrap

(1935) *Dinah: The Dartmoor pony*. London: A. & C. Black

(1936) *British Ponies: Running Wild and Ridden*. London: A. & C. Black

(1937) *Sons of Skewbald, or Castor and Pollux*. London: A. & C. Black

(1939) *Sheltie: The story of a Shetland pony*. London: A. & C. Black

(1939) *The White Buck: A New Forest story*. London: Thomas Nelson & Sons

(1940) 'A Dartmoor Bog'. In Cyril Swinson (ed.) *Twenty Animal Stories*. London: A. & C. Black (First published in *Exmoor Lass*, 1928)

(1943) *The Ninth Legion*. London: George G. Harrap

(1941) 'Ponies in a Window' and 'New Forest Ponies'. In Cyril Swinson (ed.) *Twenty More Animal Stories*. London: A. & C. Black. (First published in *Sons of Skewbald*, 1937, and *British Ponies: Running Wild and Ridden*, 1936)

(1946) *Purkess the Charcoal Burner*. London: George G. Harrap

(1947) *Alfred's Jewel*. London: George G. Harrap

(1948) *Mona: The Welsh pony*. London: A. & C. Black

(1948) *Pattern without Pain*. London: B.T. Batsford

(1949) *Our Ponies*. Harmondsworth: Penguin (Puffin Picture Books)

(1951) *Blondel the Minstrel*. London: George G. Harrap

Select bibliography of other works

Beach Thomas, Sir William (1948) *The Way of a Dog*. London: Michael Joseph (Pen and ink line illustrations)

Burnett, M.E. (c. 1919) *My First Book of Birds*. London: Thomas Nelson

Cumming, Primrose (1934) *Doney: A borderland tale of ponies and young people*. London: Country Life Limited (Pen and ink drawings and 16 full page pencil drawings)

Ellwood, G.M. (1924) 'Famous Contemporary Art Masters: Allen W. Seaby, University College, Reading.' In *Drawing and Design*, Vol. 4, New Series IV, September

Gillmor, Robert (1998) Afterword to *Allen W. Seaby 1867–1953*, Studio Exhibition No. 1 (catalogue). Lavenham: The Wildlife Art Gallery

Gillmor, Robert (1999) Foreword to *Allen W. Seaby 1867–1953* Studio Exhibition of Bird Paintings (catalogue). Lavenham: The Wildlife Art Gallery

Hale, Kathleen (1994) *A Slender Reputation. An Autobiography*. London: Frederick Warne

Hammond, Nicholas (1986) *Twentieth Century Wildlife Artists*. London: Croom Helm

Hammond, Nicholas (1998) *Modern Wildlife Painting*. Mountfield: Pica Press

Jackson, Christine (1999) *Dictionary of Bird Artists of the World*. Woodbridge: Antique Collectors Club

Kirkman, F.B. and Jourdain, F.C.R. (1910–1913) *The British Bird Book: An account of all the birds, nests and eggs found in the British Isles*. Vols 1–12. London: T.C. and E.C. Jack

Kirkman, F.B. and Jourdain, F.C.R. (1932) *British Birds*. London: T.C. and E.C. Jack

Morley Fletcher, F. (1916) *Wood-block printing: A description of the craft of woodcutting & colour printing based on the Japanese practice by F. Morley Fletcher with drawings and illustrations by the author and A.W. Seaby*. London: Pitman

Phillips, Walter J. (1926) *The technique of the color wood-cut*. New York: Brown-Robertson Co., Inc

Platt, J. (1938) *Colour Woodcuts*. London: Pitman

Sloan, Cathy (1995) 'A.W. Seaby: "....a classic tale of Victorian self-improvement"'. *Nature in Art*, vol. 3, no. 3, pp. 9–10

The Times, Obituary of Allen W. Seaby. 30 July 1953, pp. 8

Vesey-Fitzgerald, Brian (1953) *British Birds and their Nests*. Loughborough: Wills & Hepworth (Ladybird)

Vesey-Fitzgerald, Brian (1954) *A Second Book of British Birds and their Nests*. Loughborough: Wills & Hepworth (Ladybird)

Wencelius, Marguerite (1929) 'Review: Art in the Life of Mankind by Allen W. Seaby'. *The Art Bulletin*, vol. 11, no. 2, pp. 222–3

Two Rivers Press has been publishing in and about Reading since 1994. Founded by the artist Peter Hay (1951–2003), the press continues to delight readers, local and further afield, with its varied list of individually designed, thought-provoking books.